THE FIVE PARADOXES
OF MODERNITY

THE FIVE PARADOXES
OF MODERNITY

ANTOINE COMPAGNON
Translated by Franklin Philip

Columbia University Press
New York

Columbia University Press wishes to express its appreciation of assistance given by the government of France through Le Ministère de la Culture in the preparation of this translation.

Columbia University Press
New York Chichester, West Sussex
Les Cinq Paradoxes de la Modernité © Éditions du Seuil 1990
Copyright © 1994 Columbia University Press
All rights reserved

Library of Congress Cataloging-in-Publication Data
Compagnon, Antoine, 1950–
 [Les Cinq paradoxes de la modernité. English]
 The Five paradoxes of modernity / Antoine Compagnon ; translated by Franklin Philip.
 p. cm.
 Includes bibliographical references and index.
 ISBN 0–231–07576–6
 ISBN 0–231–07577–4 (pbk.)
 1. Modernism (Art) 2. Art, Modern—19th century. 3. Art, Modern—20th century. I. Title.
 N6465.M63C6613 1994
 709′.04–dc20 93–35830
 CIP

Printed in the United States of America
c 10 9 8 7 6 5 4 3 2 1
p 10 9 8 7 6 5 4 3 2 1

CONTENTS

■
■
■
■
■

Shuttling back and forth between New York and Paris—as I have been doing for the past seven years—you lose all sense of a home, that is, of feeling at home in either language and culture. Not that you miss anything; this is actually the most disturbing part of the experience. You simply carry with you everywhere a persistent sense of self-consciousness and *Unheimlichkeit*. It's as though a metal curtain drops down when you take off. You close shop on one side of the ocean; the next day you sit at a different desk in front of the same laptop computer, finishing off a sentence you jotted down in the other world. No, you miss nothing: you instantly forget all the numbers and names but those of your two or three closest friends. When you come back the curtain lifts and you remember it all again. Without this unnatural capacity to forget, you would never really be anywhere and soon would become schizophrenic. You are here and there, but a weird feeling of distance remains, like a veil between you and each world: I am no longer wholly French in Paris and clearly not an American in New York. As a result I always disagree with the received sense of things. This is the beginning of a peculiar, happy melancholy.

When I was writing this book during a leave in Paris a few years ago, I was under the impression that it was an American book: I was questioning the French meaning of *modernity*, or *modernity* as the French mean it—that is, as French—from an

American perspective. Having lived in the United States for some time, I realized the limitations of modernity as I had seen it formerly. This was not lost on some of my French readers. One of them, a high-minded intellectual and an old friend, wrote to me after the book was published: "Is it America that has made you so trivial?" What was American and trivial—note the equation—was that I did not take modernity for granted; in other words, I doubted the French faith in the avant-garde, the conviction that the future will redeem its present frustrations. This, for some of my companions of the 1970s, during which time France remained a modernist stronghold and continued to conceive of the arts through political and military rhetoric, implied nothing short of high treason. In a major newspaper, one reviewer scolded me for attacking modernity unfairly: I had contextualized its meaning and that apparently was offensive enough. "Happily," the review concluded, "some of us still believe in living at the cutting edge of history." The problem with commuting across the Atlantic is that you no longer take anything for the cutting edge. It all sounds much too self-serving. I thought I had now seen the far side of modernity.

The starting point for this awareness had been my surprise, when I first took a job in the United States in the mid-1980s, to hear everybody call *postmodern* things that I had never thought of labeling that way in France. Students came to my office with reading lists for their exams. I found these lists odd, I thought they mixed apples and oranges. When I said so, students replied that their general topic was "Postmodern Literature." Italo Calvino, Gabriel Garcia Marquez, Thomas Pynchon, John Hawkes, Robert Coover, and John Barth were included, as well as Claude Simon, Michel Butor, and Alain Robbe-Grillet, plus Marguerite Duras of course, perhaps Milan Kundera, and also—as precursors, "early-postmoderns" or "pre-postmoderns"—Jorge Luis Borges, Samuel Beckett, and Vladimir Nabokov. The combination was seasoned with some Roland Barthes, Michel Foucault, Jacques Derrida, and Jacques Lacan,

with a dash of Paul de Man. It did not seem strange at all to the students. Indeed, it sounded quite banal after a while, especially the confusion of postmodern and poststructural. I would try to argue that such lists did not make much sense outside American campuses: that the French *nouveau roman,* for instance, claimed its affiliation with the modern in its manifestos of the 1950s, or that Beckett's links with Proust and Joyce bespoke the modernism of his plays and novels. I added that the turning point between structuralism and poststructuralism was elusive in Barthes's or Foucault's works, and I suggested that national specificities rendered such catchall labels of little relevance. But the cultural misunderstandings remained.

I should add that I was not a stranger to the postmodern. The first book I wrote dealt with a theory and history of literary quotation, *La Seconde Main ou le travail de la citation* (Paris: Seuil, 1979). The word *postmodern* did not appear, but some readers saw the book as a postmodern statement because of its very topic. Quotation, which paves the way for parody and the like, often serves as a litmus test for the postmodern. Wherever there is quotation, the reader can expect the postmodern, as opposed to the modernist utopia of the tabula rasa. Quotation thus made me postmodern: I was invited to write on quotation and the city, quotation and film, quotation and politics. I now wonder whether the choice of quotation for my dissertation, back in 1974 or 1975, was not a symptom of unconscious postmodernism, even though I explained it at the time from a formal, modernist point of view. This first book was in any case read as postmodern, particularly by architects, but I myself was not willing to give the notion the overarching meaning I found was being attributed to it in New York, where everything was suddenly postmodern and one was ashamed to remain merely modern.

To grasp cultural discrepancies in the usage of the adjective *postmodern,* I suggest here that there was no need for *postmodern* in France because the French meaning of *modern* was more

inspired by the modernity of Baudelaire who was indifferent to the future than by the futuristic modernisms that followed and who protested that history would catch up with the lead they had on their own times. Baudelaire's modernity already implied most of the premises underlying the postmodern in America— its theoretical pessimism and historical fatalism, for example. There is fundamental disagreement on the words *modern, modernity, modernism* among the English, German, and French languages. In German, as Jürgen Habermas insists, *modern* is inseparable from reason and Enlightenment; breaking away from the modern is therefore identified with obscurantism and neoconservatism, examples of which Habermas finds in French poststructuralism. In France, however, where Baudelaire and Nietzsche are the most prominent moderns, modernity includes nihilism and a distrust of history and progress. This modernity reacts against modernization and is mainly artistic; it is positive only from an aesthetic point of view, whereas the modern project, according to Habermas, is philosophically and historically redemptive. The Baudelairean modern, melancholic and dandified, includes the postmodern as an awareness of the end of history and a refusal of the modernist logic of overcoming, with its dialectic of progress that recasts old religious messianisms. The postmodern seems cured of history, as Baudelairean modernity already was and as was Nietzsche in *On the Advantage and Disadvantage of History for Life*. Hence my temptation to see in the postmodern a belated understanding of Baudelaire, who had long been misrepresented by the high modernist tradition, itself identified as early as the 1880s with the avant-garde and futurism. Looking at history and not at the present as such, this tradition could only distort Baudelaire's thought while making him its prophet. But postmodernism would catch up with Baudelaire, with the modern practice of art that modernist theories of art had misrepresented. In that sense, I would defend postmodernism, understood as historical levelheadedness, consciousness of the present, liberation from messianic and eschato-

logical illusions—less the end of history than the end of histori-
cal eschatologies; but this sense is my own, idiosyncratically
developed between France and the United States. It coincides
nowhere and proves controversial everywhere. Being in between
places means that in America I object to the overuse of words
such as *postmodern*—or *political correctness* at present—but that
in France I cannot just discard them as American fads that will
soon die out.

In France, *The Five Paradoxes of Modernity* was the first book
I published that evoked such strong reactions; it appeared at a
time when I had also started reacting against certain things
French. An anecdote here might give a sense of the cultural mis-
adventures attached to traveling. This book, in fact, had begun
with a series of lectures at the Ecole Polytechnique during my
first leave from Columbia University. Friends at the Poly-
technique, where I had studied and later taught, asked me to
give some talks on modern culture there. The Polytechnique is a
peculiar place, nominally an engineering school but really the
seedbed of the French elites and until recently an all-male insti-
tution. Traditionally some time is devoted to culture, which is
not a bad idea in itself, but too insular in its application. My
intention was to open up the students' horizon. I thought I
would give five lectures and ask a woman friend, who also
teaches in the United States, to give the middle one. She came,
spoke of Viennese modernity, a subject that was missing from
my presentations. Afterwards she told me that all through her
talk, a male student in the last row had been sending her kisses
and making gestures. Now, it is difficult to imagine this kind of
behavior taking place today in an American institution of
higher learning. Seen from the French perspective, "political
correctness" is just another American fad like postmodernism. I
myself object to instances of feminist fundamentalism in the
United States, but I have grown accustomed to expecting some
degree of consideration for the other—call it *correctness* if you
will—that I would not mind finding on the other side of the

water as well. On political correctness, modernity, or post-modernity, there can be no Franco-American understanding. So this book was bound to make some of my friends unhappy. They thought of me as a turncoat: I had renounced the modernist and avant-gardist faith of our youth in the 1960s; apparently I was spoiling the party. But is that so? I was trying to make sense of a couple of words—*modern* and *postmodern,* essentially—on both sides of the ocean. Later, those friends who had rejected the book told me that their children seemed to have fewer problems reading it.

If I am right, however, in describing this book as introducing the French public to the American view about modernity, how will it be read here in the United States? Everything I put forward in this book about the modern and the postmodern might sound commonplace, and this time with good reason. Obviously American readers are more familiar with Clement Greenberg or Paul de Man than are the French. Written between Paris and New York, this book may antagonize readers here in the United States as well as on the other side of the Atlantic. But I hope it can also serve symmetrically as an introduction to modernity as seen from abroad, as a discussion about the diverse meaning of notions central to both of our cultures. On issues that have never ceased being controversial, my ambition is to find my own way and help the reader find his or her way, if only to the middle of the ocean.

Paris, August 1992

PREAMBLE: MODERN TRADITION, MODERN BETRAYAL

> If he extols himself, I humble him.
> If he humbles himself, I extol him.
> And always contradict him.
> Until he comprehends
> That he is an incomprehensible monster.
> —Pascal, *Pensées*

The bourgeois can no longer be "épaté." He has seen it all. In his eyes modernity has become a tradition, and the only thing that remains at all startling to him is the fact that tradition is beginning to pass for the height of modernity. Not long ago the juxtaposition of these two terms seemed a contradiction or oxymoron such as the "flame so black" with which Phèdre burned or the "gloomy beacon" to which Baudelaire compared the idea of progress. What is traditional has long stood in contrast to what is modern, not to mention modernity or modernism: the modern broke from tradition and tradition resisted modernization. Etymologically, tradition is the handing down of a model or belief from one generation to another and from one century to the next: it presupposes allegiance to an authority and fidelity to an origin. It would thus be absurd to speak of a modern tradition, for this tradition would consist of breaks or ruptures. Certainly these breaks are conceived as new beginnings, inventions of ever more basic origins, but an end is immediately put to these new beginnings and these new origins are destined to be immediately left behind. Since each generation breaks with the past, the rupture itself might be said to

constitute the tradition. But is not a tradition of rupture neces-
sarily both a negation of tradition and a negation of rupture?
The modern tradition, wrote Octavio Paz in his *Convergences,* is
a tradition that has turned against itself, and this paradox
bespeaks the fate of aesthetic modernity, which is contradictory
in itself; it both affirms and denies art, simultaneously pro-
claiming its life and death, its rise and fall. The combination of
opposites exposes the modern as a negation of tradition, which
is inevitably the tradition of negation; it points out its own apo-
ria or rational impasse.

The English phrase *modern tradition* is less paradoxical than
its French equivalent, for it is used to designate the aesthetic
viewpoint of the historical period that began in the mid-nine-
teenth century with the challenge to academicism. The first
moderns and founders of this new tradition were Baudelaire
and Flaubert in literature, Courbet and Manet in painting, who
were followed by the impressionists and the symbolists, by
Cézanne and Mallarmé, the cubists and the surrealists, and so
forth. A weighty volume entitled *The Modern Tradition,* pub-
lished in the United States in the mid-1960s, is an anthology of
the classics of modernity, a bible of the modern religion from
Kant to Sartre and from Rousseau to Robbe-Grillet. In English,
"modern tradition" contrasts with the "classical tradition" that is
more acceptable since it designates the passing down of ancient
culture through the ages in the West and the vicissitudes of his-
tory. Though less striking, the paradox nonetheless remains.
Classicism and tradition may well go together, but the modern
tends to suggest a betrayal: the betrayal of tradition but also a
denial of itself.

How can we characterize this contradictory and self-destruc-
tive tradition, which resembles Pascal's "incomprehensible mon-
ster" or Baudelaire's *héautontimorouménos?* It is "the wound and
the knife," "the slap and the cheek," "the limbs and the rack,"
and "the victim and the executioner." Modernity's slogan par

excellence was to "create the new." At the conclusion of his *Salon of 1846,* Baudelaire thus called out for the "advent of the *new!*" "Make it new!" Ezra Pound was later to proclaim. And if we no longer offend logic by speaking of a modern tradition, it is because we somehow got out of it, as so many pompous predictions of the end of modernity would have us believe. After the event it looks as though the modern tradition practiced what Valéry called the "superstition of the new." But here the paradox reappears: how much authentic value can the new retain amid the modern idolatry that surrounds it, forcing it to renew itself without end, other than what Nietzsche, who attacked modernity as decadence, called the eternal return, that is, the return of the same thing with a new name—fashion or kitsch? The conformity of nonconformism is the vicious circle of the avant-garde. The new, however, is no more simple than the modern or modernity: the melancholic veneration Baudelaire bestowed upon it seems very different from the futuristic enthusiasm of the avant-garde.

The modern tradition started with the birth of the new as a value, for the new has not always been seen as a value. But the very word *birth* is disturbing, for it belongs to a particular genre of the historical narrative, precisely the modern genre. Modern history is recounted in light of its end result: it dislikes paradoxes that elude its scheme, and it resolves or dissolves them by critical elaborations; it is written on the basis of assorted concepts of tradition and rupture, of evolution and revolution, of imitation and innovation. Genealogical and teleological, the historical narrative prejudges the destiny of art. It is Baudelaire's "gloomy beacon":

> There is yet another, and very fashionable, error which I am very anxious to avoid like the very devil. I refer to the idea of "progress." This gloomy beacon, invention of present-day philosophizing, licensed without guarantee of Nature or God—this modern lantern throws a stream of darkness upon all the objects

of knowledge; liberty melts away, discipline vanishes. Anyone who wants to see his way clear through history must first and foremost extinguish this treacherous aid.

Applied to art, the idea of progress is "a gigantic absurdity, so ludicrous as to touch upon the horrendous." But is there any other way to describe the destiny of art? Can we dissociate the consecutive and the consequent? Can we maintain the paradoxes? Can we forget the ideas of progress and dialectics by which, in its own eyes, modern tradition has redeemed itself? If the expression of modern tradition has a meaning—a paradoxical meaning—the history of this modern tradition will be contradictory and negative: it will be a story going nowhere. Thus we embark on a contradictory history of the modern tradition or, what amounts to much the same thing, on a history of the contradictions of the modern tradition.

In the gardens of the Villa Favorita in Lugano, two tourists exchanged the following words: "Are there any impressionists?" "Only some Goyas." This is how the history of painting is commonly retold, retrospectively, from Monet through Manet to Goya, with posterity's hindsight following a progressivist logic based on what has prevailed and been handed down: it is a faultless dialectic of modern art's successes. But if the modern is a break—an irreparable rupture—doesn't a progressivist history necessarily misjudge what was modern in, say, Goya or Manet?

In place of these putative turning points or of this gallery of exemplary figures, we ought to write a paradoxical history of the modern tradition that is conceived as a story with holes in it, an intermittent chronicle. For it is surely the hidden face of each modernism that is the most important: the screened-out aporias and antinomies of orthodox narratives. Our contemporary awareness of modernity, which we willingly call postmodern, allows us to economize on the logics of elaboration that have marked the modern age. The story of the passed-over elements of history, which Walter Benjamin called for, will be less that of

minores to be reevaluated than that of the very modernity of the greatest moderns, as such unsurpassable and hence ignored by modern histories.

In this work I consider five paradoxes of modernity: the superstition of the new, the religion of the future, the mania for theory, the appeal to mass culture, and the passion for repudiation. The modern tradition goes from one dead end to another; it betrays itself and it betrays true modernity, which consists of the rejects of this modern tradition. The conclusions that I draw, however, are not pejorative: "insignificance resulting from greatness and the greatness of insignificance," said Pascal speaking of man, and "to know oneself to be insignificant is to be great."

Each of the five paradoxes of the aesthetics of the new is linked to a crucial moment in the modern tradition, a moment of crisis —because this tradition is made up wholly of unresolved contradictions. The first crisis can be set in 1863, the year of Manet's *Déjeuner sur l'herbe* and *Olympia,* but let us think rather of an entire galaxy of artists contemporaneous with Baudelaire. The year 1913 sets the scene for the second paradox, with Braque's and Picasso's collages, Apollinaire's calligrams, Duchamp's ready-mades, Kandinsky's earliest abstractions, and Proust's *Remembrance of Things Past.* The third paradox can be dated to 1924, with the appearance of the first *Surrealist Manifesto.* The fourth moment, from the beginning of the Cold War through 1968, is the one most difficult for me to talk about, for it corresponds to the modernity in which I myself came to consciousness and that, when I recall its enthusiastic activism, now bores or depresses me: leafing through the album of modernity brings on melancholy, as the licentious *estampes* did for Baudelaire.

At last we come to the 1980s, scene of the final paradox. This will be easier for me to discuss, as this particular modernity is no longer my own, and furthermore it is not French: two facts

that make me merely an onlooker. But we should beware of the xenophobic condescension with which the French, who still think they were the ones to invent modernity, often regard this postmodernity. Because the future has been pawned and can now be perceived only as an end of the world—the threat of atomic disaster, the third-world debt, the destruction of the ozone layer—the collapse of the modern world has become a commonplace, and revisionism is going full steam ahead: at the Musée d'Orsay academicians of the Second Empire and pomposities from the Third Republic hang side by side with the greatest artists. It is the revenge of Manet's teacher Thomas Couture! Is the postmodern the cutting edge of the modern or its repudiation? Has the cult of the future been abolished? Are we cured of the superstition of the new?

THE FIVE PARADOXES
OF MODERNITY

ONE

■
■ **THE PRESTIGE OF THE NEW:**
■ **BERNARD OF CHARTRES,**
■ **BAUDELAIRE, AND MANET**
■

—innovators are free! to execrate their forbears: we are
at home and we have the time.
—Rimbaud, letter to Paul Demeny, May 15, 1871

M *odern, modernity, modernism:* these words have
different meanings in French, English, and German; they do
not refer to clear and distinct ideas, to closed concepts.
Baudelairean modernity, which I shall discuss further on, con-
tains within it its opposite, a resistance to modernity. All mod-
ern artists, from the romantics on, have been divided and some-
times torn apart. Modernity, willingly, adopts a provocative
manner, but its flip side is desperation. Let us not fall victim to
the mirage of "overcoming," going beyond, moments of break-
ing the limits in order to resolve contradictions whose very
nature is to remain insoluble; let us guard against reducing the
ambiguity peculiar to the new as a fundamental value of the
modern age. For minds trained in the exact sciences and mathe-
matical logic, it is hard to discard rational habits, but the world
of symbolic forms obeys a different logic and demands instead
an intuitive mind. In this area, there is no way to arrive at neat
definitions resolving all ambiguities. Instead, here is a tangled
skein of words that I propose to sort out. They come in pairs:
ancient and modern, classical and romantic, tradition and origi-
nality, routine and novelty, imitation and innovation, evolution
and revolution, decline and progress, and so on. These pairs are
not synonymous, but they clearly form a paradigm and overlap.

They are also contradictory. For this reason, authors who speak relevantly of modernity are often difficult to read: Walter Benjamin's analyses, for example, slip through the fingers like sand. I will therefore limit myself to drawing the map of modernity, which, according to Gianni Vattimo's felicitous phrase, is "the epoch in which Being is reduced to the *novum.*"

After presenting a short genealogy of the new as a value, I will offer, as an example of the first paradox of modernity, the ambivalence of the first moderns, particularly Baudelaire and Manet. In the spring of 1888 Nietzsche contrasted two types of decadents, i.e., moderns: "The typical *decadents,* the Goncourts, the Richard Wagners for example, who feel *necessary* in the depravity of their style and thereby lay claim to superior taste, those who want to impose a law on *others,* must be distinguished from the *decadents* who have a guilty conscience and are *decadents* in spite of themselves." Beside the self-confident decadents—I refer here to the earliest historical avant-gardes rather than to Wagner or the Goncourts—Nietzsche does not quote the decadents or moderns who were so in spite of themselves, but it is not unlikely that he was thinking of Baudelaire.

∎

"It is necessary to be absolutely modern," proclaimed Rimbaud. With Rimbaud the slogan of the modern bursts out as the violent rejection of the old. The term *new* is repeated throughout his famous "letter of the seer" of May 1871—at the height of the Paris Commune—as, for example, in this reservation he expressed about Baudelaire's style: "Inventions of the unknown require new forms." This inevitably reminds us of the final melancholy line of Baudelaire's poem, "Le Voyage," and of the 1861 edition of *Fleurs du Mal,* plunging "*Au fond de l'Inconnu pour trouver du* nouveau!" [To the bottom of the Unknown to find the *new!*] At first the "new" according to Baudelaire and the "new" according to Rimbaud seem to be unrelated. Baudelaire's "new" is desperate—such being the meaning of *spleen* in

French—it is wrested from catastrophe, from the disaster of tomorrow. "The world is going to end": thus begins the most detailed fragment from Baudelaire's diaries, and one of the most pessimistic, which Walter Benjamin in 1939 saw as prophesying the imminent war. Rimbaud, on the other hand, assigns the poet the mission of making himself a "multiplier of progress!" True, despite this initial promise, he soon ended up in "silence," reaching the frontiers of art in short order.

I need now to go further back to trace the earlier origin and genealogy of these notions. Though the term *modernity,* meaning the character of being modern, first appeared in 1823 in Balzac, before it was identified with Baudelaire, and though the term *modernism*—in the sense of a taste, most often judged excessive, for what is modern—was first used by Huysmans in the *Salon de 1879,* the adjective *modern* is much older, according to Hans Robert Jauss who has retraced its history: *modernus* appeared in low Latin toward the end of the fifth century, derived from *modo* (just now, recently, now). *Modernus* designates not what is new, but what is current, contemporary, of the present. The modern thus contrasts with the old or the ancient, that is to say, the bygone past of the Greco-Roman culture. The *moderni* versus the *antiqui*—that is the initial contrast, that of the present versus the past. As Jauss suggests, the entire history of the word and its semantic development has been one of shrinking the time lag between the present and the past; in other words, the speeding up of history. It matters little whether this acceleration is a reality or an illusion, whether or not more things happen in a moment of modern times than in a moment of antiquity; what counts is the perception of time. The eternal return of the same can also speed up its pace. The same is true of fashion, which is never very far from the modern.

When the word first appeared, time was not even at issue. The split between the ancient and the modern does not involve time; the separation between Greco-Roman antiquity and the medieval *hic et nunc* is total and absolute: the conflict between

the ideal and the commonplace. Today—Baudelaire already noted this phenomenon—the modern is immediately outdated, contrasting less with the timeless classical than with the out-moded, that is, what has gone out of fashion or what was mod-ern yesterday: time has speeded up. But this acceleration began a long time ago. Whereas in the fifth century *modernus* did not imply the idea of time, by the twelfth century—during what is called the first Renaissance—the time lag defining the *moderni* as opposed to the *antiqui* was of only a few generations; the question has been much debated whether as early as the twelfth century the notion did not already contain the idea of a certain progress between the *antiqui* and the *moderni,* an idea linked to our own conceptions of the modern era.

There is a famous medieval image that foreshadows—at least for the debates on its interpretation—the paradoxical feature that throughout its history will remain attached to the modern as a negation, including the negation of itself. The image appears on one of the stained-glass windows in Chartres cathe-dral, representing the apostles sitting on the shoulders of the prophets: on the south side for example, Saint John is perched on the shoulders of Ezekiel and Saint Mark on the shoulders of Daniel. Symbolizing the link between the Old and the New Testaments, this image has become, at the cost of some confu-sion, an emblem of the relation between the ancients and the moderns. It has often been associated with the commonplace first uttered in the twelfth century by Bernard of Chartres: *Nanus positus super humeros gigantis* [We are like dwarfs perched on the shoulders of giants]. The image and the phrase probably have nothing to do with each other as far as their origins are concerned; comparing the apostles to dwarfs—in contrast to the prophets appearing as giants—does not fit the Christian conception of the relation between the two testaments. Thus, it is in the manner in which they were perceived that the two sym-bolisms became mingled in a single commonplace; but this is no less significant. And if the image and the saying have been

taken to be synonymous, the cause is no doubt their shared ambiguity. It consists in the following: dwarfs are smaller than giants but, perched on giants' shoulders, they can see further. It is unclear which of the two aspects of the moderns' situation vis-à-vis the ancients the commonplace was emphasizing; are the moderns smaller or are they more perspicacious? Once the two aspects are identified as the same, this emblem of progress becomes an emblem of decadence. Even before being invented as such, progress already implies decadence.

Even so, before it became linked to the relation between apostle and prophet, the image of the dwarf on the shoulders of the giant was probably merely a scholastic illustration used by the grammarians as a stimulus for imitating ancient models. In his "De l'expérience," Montaigne uses it in a way that is anything but progressivist: "Our opinions are grafted one upon the other. The first one serves as a stem for the second, the second for the third. We thus climb from one step to the next. And as a result the one who has risen the highest is often more honored than he deserves; for he has risen only by a tiny degree over the shoulders of the next to last." Therefore it would be anachronistic to see in this image a philosophy of history that would imply the idea of overcoming, the belief that between the old and the new there is historical progress or, at the very least, some progress in knowledge. The Christian conception of time does not allow this; admittedly it implies an idea of progress, but a spiritual or typological progress, making the cohesion between the Old and New Testaments the model of the relation between present time and eternal life, and not historical progress.

The adage that governs the Catholic relation between the present and tradition, that is, the relation between current texts and those of the past that hold authority—those of the fathers and doctors of the Church—is "*Non nova, sed nove*" (not the new, but anew), in the words of Vincent of Lérins. The idea is to speak in new terms, but avoiding the introduction of the slightest novelty. This is how the Christian tradition defines

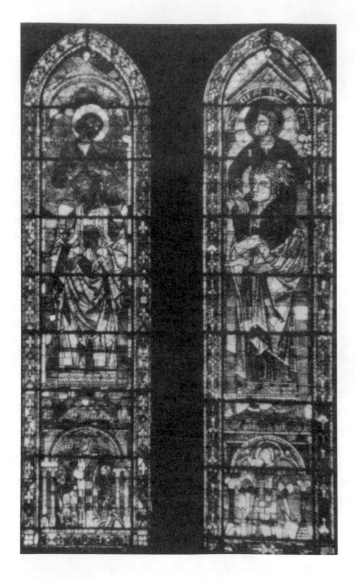

Chartres, Saint John on the shoulders of Ezekiel
and Saint Mark on the shoulders of Daniel.

itself, for perfection existed in the beginning before sin; and if it also lies in the future, this future is thought of not as a continuation of earthly time but as another time, as eternity.

The invention of progress was indispensable for the adjective *modern* to acquire the nebulous sense it has now taken, that is, as Octavio Paz has noted, the definition of a positive sense of time. It is neither cyclical, as in most of the ancient theories of history, nor typological, as in Christian doctrine, nor negative, as in most of the thinkers of the Renaissance: Machiavelli, Jean Bodin, and probably Montaigne. Admittedly, a positive idea of time—that is, as a linear, cumulative, and causal development—implies the Christian notion of time; but it opens out into an infinite future. This positive idea of time was applied to history, to the history of art in particular, as a law of perfectibility that was postulated in the sciences and technology during the sixteenth century. Thus, in a paradox based on the parallel between the ages of life and of humanity, Francis Bacon reversed the relationship between the ancients and the moderns: the ancients, in relation to us, were like childhood in relation to the wisdom of old age. "It is we who are the ancients," said Descartes, and Pascal did not notice Montaigne's skepticism when he repeated the image of giving someone a leg up: "From there, we can discover things that were impossible for them to perceive. Our vision is more extensive, and although they knew all that is to be observed in nature as well as we do, nevertheless they did not know as much as we do, and we see more than they did." Pascal wrote this in the *Préface sur le traité du vide,* in which he shows that Western scientific progress since the Renaissance, seen as the abolishment of authority and the triumph of reason, is the model for our modern conception of time: successive, irreversible, and infinite.

The assertion of progress in the realm of taste and not merely in scientific and philosophical knowledge—in other words, the artistic and literary superiority of moderns over ancients—made its first appearance during the quarrel over the ancients and the

moderns that occurred at the end of the seventeenth century. Thus doubt was cast on the foundation of classical aesthetics and ethics, which saw reverence for, and imitation of, the ancients as the only criterion of beauty, and asserted the timeless values of ancient models. Charles Perrault, author of *Parallèle des anciens et des modernes,* and Bernard de Fontenelle were the chief critics of tradition and authority. But the most vigorous argument against traditional authority was found in Spinoza's *Tractatus Theologico-Politicus,* with its assertion of the historical nature of the Bible. From the viewpoint of the moderns, the ancients were inferior because they were primitive and the moderns·superior because of progress—scientific and technological progress, social progress, and so forth. Literature and art followed the general movement, and the negation of established models could be seen as the blueprint for aesthetic development.

From then on an aesthetics of the new became a possibility. Some will argue that this possibility had always existed. This is indeed true of the aesthetic of surprise and the unexpected, as in the baroque, but not true of the aesthetic of change and negation. The eccentric or the extravagant that has always existed on the fringes of tradition—the blasphemy, satire, and parody that always accompany traditional allegory—is different from the heterogeneous, which seeks to be truly something *other* and not just rebellious. "Because beauty is always surprising, it would be absurd to suppose that what is surprising is *always* beautiful," wrote Baudelaire, who best summed up this debate. His proposal—"The Beautiful is always bizarre"—gave rise to a cult of the bizarre, but only at the cost of a misinterpretation that the poet had foreseen and denounced.

Through one of those ironies of history that pervades the modern tradition from end to end, one of the essential—and explicit—arguments of the moderns against imitation holds that imitation succeeds only with geniuses who can equal the greatest names of antiquity. But imitation is not suitable to mediocrities, who succeed merely in making themselves look

foolish in comparison with the ancients. Thus the modern the-
sis seems marked at the outset by a concession. Besides, how can
we not but be struck now by the fact that the ancients were
greater artists than the moderns? Are Philippe Quinault,
Charles de Saint-Evremond, Charles Perrault, and Bernard de
Fontenelle any match for Nicolas Boileau, Racine, La Fontaine,
and Bossuet? But this is beside the point, for, the fact is, the
moderns who came out in favor of new genres, such as the
opera, the tale, the novel, and a literature of sheer diversion,
were right about the future. Even if they themselves still
believed in timeless perfection, judging it to be simply inaccessi-
ble, their argument in favor of the relativity of beauty, thereafter
conceived in national and historical terms, swept away that of
the ancients.

With the assertion of progress all through the eighteenth
century and up until Condorcet's *Outline of a History of the
Progress of the Human Mind* in 1795, we are ready to set forth
the following pair: classicism and romanticism. Strangely
enough, the claim of the moderns involved a reference to the
Christian Middle Ages and to the romances of chivalry, but here
it was a national past that was being exalted at the expense of
the Greek and Latin classics. *Romantic* means *as in the old
romances,* and in the Age of Enlightenment the reference was
originally pejorative; after a detour through England it returned
to France having acquired a noble meaning that distinguished it
from *romanesque* and assimilated it to *modern,* with a Christian
sense in contrast to antiquity. The most important thing, prob-
ably, is that *romantic* now added to *romanesque* a new dimen-
sion of melancholy and despair that would remain inseparable
from the modern faith in progress and the recognition of our
endless historicity. Contrasting with the classical aesthetic,
whose ambition was to transcend time, the romantic aes-
thetic—as can be seen in the *mal du siècle* starting with
Chateaubriand's *René*—rests on a malaise with relation to time
and an awareness of the incompleteness of history. An aesthetic

of the new, of endless starting over, seemed unthinkable until the French Revolution provided it with a stunning historical precedent.

The final moment that would crystallize the constellation of the modern and the new into what we still perceive it to be, stretches from Stendhal to Baudelaire. As I have already noted, the history of the idea of the modern since the Middle Ages, according to Jauss, is that of the reduction in the time lag that separates the modern from the old. With classicism and romanticism, the "ancient" and the "modern" still denote two aesthetic options that are not wholly reducible to the passage of time. With the coming of "modernity," however, the distinction between the present and the past becomes ephemeral. The antithesis between classical and modern tastes ceases to be meaningful, with classicism henceforth seen only as yesterday's romanticism. This idea is common to many nineteenth-century writers and appears in a number of works that have more or less to do with the "romanticism of the classics." The idea is that the classics were the romantics of their time, while the romantics will be the classics of tomorrow. As Ferdinand Brunetière was to write at the end of the century, the romantics of today are the classics of tomorrow, "rather like the way the most ill-behaved boys, so they say, later make the best family men." The opposition of classicism and romanticism, of the ancient and the modern, is an opposition between two presents, two current times, yesterday and today, today and tomorrow. This idea was clearly formulated by Stendhal in 1823, in his *Racine et Shakespeare*. Stendhal first defines "romanticism" as "an art of presenting people with literary works that, given the current state of their habits and beliefs, are capable of giving them the greatest possible pleasure." He strongly emphasizes the relation between art and the topical: the romantic is one who appears faithful to today's world. Hence the abrupt follow-up: "Sophocles and Euripides were eminently romantic." This is said in jest, but it was to make possible what we call modernity: "I suggest with-

out hesitation that Racine was a romantic; to the marquises at the court of Louis XIV he offered an image of passion, tempered by the *extreme dignity* that was then in fashion." Finally—and this too is a remarkable observation—the connection between art and the topical involves a close dependence with regard to history: "Within historical memory, never did the customs and pleasures of the people change more rapidly and more completely than between 1780 and 1823; and writers still want to give us the same kind of literature!" We should not be surprised at the role taken by the French Revolution in this new consciousness. Before Baudelaire, every characteristic of the modern had already been enumerated; we even find the anticipation of a dogma that would become typical of avant-gardes and that is not in the least Baudelairean: beauty exists only in the eyes of the public for which it was created, it is of this day and age. Instead of being thought of as timeless beauty, the classical is limited to the beautiful of yesterday, which means that it is no longer beautiful at all. Since contemporary art is the only value, yesterday's art is no longer art. We have not quite reached this point here, but the trend is implied in Stendhal's thesis and will lead to the avant-garde snobbery end of the century: witness the young Madame de Cambremer in *Remembrance of Things Past,* for whom, after Wagner, Chopin is not music and after Monet, Manet is not painting. The topical of today becomes the classicism of tomorrow, according to a purely negative definition of classicism, writes Jauss, "like the prestige once achieved by past works, and no longer like a perfect thing that is shielded from the effects of time." Modernity falls continually into classicism and becomes its own antiquity. Taken in this sense, it is no longer opposed to anything, though tomorrow's modernity will reject today's. Art is linked to progress and historical time.

Today the object is to please. By placing the accent on change and relativity, on the present, Stendhal identifies taste with fashion. But his doctrine is fraught with the evolution

toward the avant-gardes, according to which contemporary society is not prepared to welcome the art of the present. The artist must then wait for the future to confirm his intuition and do him justice: "It seems to me," wrote Stendhal, "that the writer needs to have almost as much courage as a warrior." Even if he disapproves of the confusion between the political and the aesthetic that became widespread after the French Revolution, and the romantic myth of the writer as prophet, his definition of an art of the present anticipates one of the fatal contradictions of modernity, which notes that contemporary society for whom it is intended is hostile to it, and consoles itself with the idea that the future will prove it correct.

2

As the most perspicacious observer of the nineteenth century, Baudelaire more than anyone else saw the effects of the identification of art with the life of today, first put forth by Stendhal. Though he felt ambivalence toward this modernity, which he is said to have invented, Baudelaire enjoyed the new evanescence of beauty, but resisted it, judging it to be a dead end, a decline linked to the modernization and secularization he loathed. From the start, Baudelairean modernity is contradictory, since it reacts against social modernization, the industrial revolution, and so forth. Aesthetic modernity is essentially defined by negation: antibourgeois by nature, it declaims against the alienation of the artist in a philistine and conformist world dominated by bad taste. Hence the demand, also contradictory through its determination to cling to the present, for an art that is autonomous and nonproductive, gratuitous and controversial, that will *épater le bourgeois*. Modernity projects its dualism onto the other, the bourgeois, in whom, in Valéry's words, "the artist discovers and defines his opposite." "We also impose on it contradictory properties, for we make it both a slave of routine and an absurd partisan of progress." It is to this dualism or duplicity of modernity that its destiny can be said to have been pledged.

For Baudelaire modernity was embodied in two differing and successive artists. In Delacroix, notably in the *Salon of 1846*, in which Baudelaire still shared the romantic vocabulary of Stendhal: "For me, romanticism is the most recent, the latest expression of the beautiful." Or: "To say the word *romanticism* is to say modern art." Modernity is the choice of the present versus the past: it depicts its own time, therefore contrasting with academicism and relying on the subject. Referring to Delacroix's *Dante et Virgile*, Baudelaire speaks of "a true signal of revolution" and attributes to the painter "the latest expression of progress in art." Before being "physically depoliticized" by the coup d'état, Baudelaire still believes in progress and the causal chain of history. The doctrine of progress is justified through determinism and positivism, even before it is confirmed by Darwinism: "But take away Delacroix and the great chain of history is broken and tumbles to the ground." Delacroix is a moment, a necessary link in the chain of history, that is, the history of those works that were modern in their own time.

Later, in *Le Peintre de la vie moderne* written in 1859–1860 and published in 1863, he sees Constantin Guys as one who fully realizes modernity, according to a complex, dual conception that still is at work today. Guys was a newspaper reporter, the equivalent of a contemporary press photographer; he focused on the event, crystallized the ephemeral, and dispatched his sketches to the daily papers, which drew instantaneous prints from them to illustrate news stories such as the Crimean War. In Guys, Baudelaire finds the ideal combination of moment and totality, movement and form, modernity and memory. "The pleasure we derive from the representation of the present is due not only to the beauty with which it can be invested, but also to its essential quality of being present." This conception of the present as the rejection of history and temporality is close to that expressed by Nietzsche in his 1874 *On the Advantage and Disadvantage of History for Life*. Nineteenth-century historical

consciousness reacts to the discovery of the hopeless seriality of all things by imposing order on existence in the narrative. But the meaning of the present, writes Baudelaire, remains constitutive of all aesthetic experience. The paradox, however, is in the very expression "representation of the present," which, according to Paul de Man, establishes a distance relative to the present while simultaneously asserting its immediacy. Is the representation of the present, the memory of the present, still the present? Moreover, Baudelaire immediately comes to an analysis of the connections between art and fashion that define Guys's modernity:

> He is looking for that quality which you must allow me to call "modernity"; for I know of no better word to express the idea I have in mind. He makes it his business to extract from fashion whatever element it may contain of poetry within history, to distill the eternal from the transitory ... By "modernity" I mean the ephemeral, the fugitive, the contingent, the half of art whose other half is the eternal and the immutable ... In short, for any "modernity" to be worthy of one day taking its place as "antiquity," it is necessary for the mysterious beauty which human life accidentally puts into it to be distilled from it.

Understood as a sense of the present, modernity cancels out any relation to the past, conceived simply as a succession of individual modernities and of no value for discerning the "character of present beauty." Imagination being the faculty that brings on an awareness of the present, it presupposes the forgetting of the past and the acceptance of the immediate. Modernity is thus a consciousness of the present as present, without past or future; it connects only with eternity. It is in this sense that modernity, rejecting the comfort or the entrapment of historical time, represents a heroic choice. To the perpetual and irresistible movement of a modernity that is enslaved by time and devours itself, to the obsolescence of an endlessly renewed novelty that denies the novelty of yesterday, Baudelaire contrasts the eternal or the timeless. It is not the ancient, nor the classical, nor the romantic

that one after another have been emptied of substance. Modernity stems from a recognition of the dual nature of beauty, which also means the dual nature of man.

In his *On the Advantage and Disadvantage of History for Life* Nietzsche too would stress the historical ailment of modern man, made of him an epigone, an imitator, unable to create anything really new: this is why to his mind modernity and decadence would mean the same thing. Like Baudelaire again, he did not see that progress or history, which went from one renewal to the next in the realm of artifice, held any possibility of overcoming modernity or emerging from decadence. Only religion or art—in this case the music of Wagner, from which Nietzsche had not yet turned away—through their "nonhistorical" or "suprahistorical" power, seems to him capable of curing man of history and of offering an eternal quality to existence. Rejecting history and progress, Nietzsche reconciles modernity with eternity as the only way out of decadence. But the consequence of this for both Baudelaire and Nietzsche—though in the end the latter would cease to consider modernity in terms of art—the recognition of modernity implies a disavowal of modernity, at least in the sense in which art is turning toward the life and world of the present, sublimates them and in so doing places them in the realm of the eternal. The city, the people, and the everyday that are the subject matter of the *Fleurs du Mal* and *Spleen de Paris* become poetic, less for themselves, however, than in the context of a plan that denies them and extracts from them material for renewing great art through the imagination that imbues them with correspondences.

The choice of Guys as a hero of modern life may come as a surprise, yet he perfectly illustrates the ambivalence of Baudelairean modernity and all true modernity since then, which is also a resistance to modernity, or at any rate, to modernization. Baudelaire considers the past to be useless for seizing modernity, while at the same time he regrets the disappearance of a noble age and the inroads of bourgeois materialism. Not only does

Guys represent a genre, the newspaper sketch (which is soon to give way to the photograph, itself truly modern and scorned by Baudelaire), but, laying claim, with some nostalgia, on Guys, Baudelaire leaves aside Courbet and Manet, though he knew them well and figured prominently in their latest paintings: the *Atelier* in 1855, and *La Musique aux Tuileries* in 1862. Consistent with his admiration for Delacroix, Baudelaire judges Courbet and Manet to have failed because of their positivism, because they painted what they saw without imagination. Going further than Delacroix and Guys, David's *La Mort de Marat* basically remains the model of the modern painting that Baudelaire really admires, that is, a painting with a modern subject:

> All these details are historical and real, as in a novel by Balzac; the drama is there, alive in all its pitiful horror, and by a peculiar stroke of brilliance that makes this painting David's masterpiece and one of the great marvels of modern art, there is nothing trivial or ignoble about it. The most astonishing thing about this unusual poem is the fact that it was painted with great speed, and when you think of the beauty of the drawing, the mind boggles. This is food for the strong and a triumph of the spiritual; cruel like nature, this painting has all the perfume of the ideal.

This passage dates from 1846, but it offers the key to his lack of appreciation of Courbet and Manet—whom he judged to be lacking in nobility because they were devoid of idealism and spirituality—and his preference for Guys. In painting, Baudelaire dreams of a modern subject executed with an academic technique. This is why, on the basis of their speed of execution, he praises the genres of improvisation—sketches, water colors, etchings—rather than another technique in painting, the *non-finito* in oils.

In Guys, what Baudelaire really loves is the modernity of the subjects—the women, the wenches, the dandy, the society during the Empire, and so on—he praises the painting of modern reality rather than the reality of modern painting. So we must

then reinterpret the features of modernity he discovers in the reality depicted by Guys, by applying them to the painting of Courbet and Manet: incompleteness, fragmentation, the lack of totality or meaning, the critical eye. Once they are understood in a formal context, all these features help destroy the illusion that results from the geometrical perspective and the flattening of the painting and that goes together with its loss of meaning.

Here then are some of the features of modernity, in line with what Baudelaire says about Guys—because even though Baudelaire was mistaken about the modern artist as a person, these features can still be found in a modernity that relies less on subjects or themes than on the very substance of painting itself. I offer four of them:

1. The nonfinished, a subject of criticism that was directed at all the artists of the modern tradition after Courbet and Manet, particularly the impressionists—and also Baudelaire's prose poems, for the prose poem is the equivalent to Guys's drawing. Baudelaire justifies this by the rapid pace of modern life: "[I]n everyday life in the metamorphosis of external things . . . there is a rapidity of movement that requires from the artist a similar speed of execution." Here again the modern world is characterized by what escapes the elitist culture because of its ordinary, its popular and urban facets. Nevertheless, "at any stage of its execution, each drawing has a sufficiently 'finished' look; call it a 'study,' if you like, but in this case a perfect study." In this balanced formula, art recaptures its eternal value. Baudelaire often protests against the "polish" so appreciated by the Salon's juries and mainly represented by Ingres and his school; he also praises Boudin's watercolors and Manet's engravings, which capture the undulation of time. But as far as the *non-finito*, he says nothing about Courbet's knife paintings or Manet's loose execution.

2. Fragmentation is another criticism perpetually leveled against the moderns. They were said to be painting details,

small glimmerings. Baudelaire also touches upon this point when he mentions what he calls Guys's mnemonic art, as opposed to an art that depicts nature.

> An artist with a perfect sense of form, but accustomed to relying above all on his memory and his imagination, will find himself at the mercy of a riot of details, all clamoring for justice with the fury of a mob in love with absolute equality. All justice is trampled underfoot; all harmony sacrificed and destroyed; many a trifle assumes vast proportions; many a triviality usurps the attention. The more the artist turns an impartial eye on detail, the greater is the state of anarchy. Whether he be longsighted or shortsighted, all hierarchy and all subordination vanish.

The context of this discussion of detail, on the total or fragmentary work of art, is clearly political and social. The secret target here is universal suffrage, instituted in 1848, as well as the increase of individualism that is criticized for eliminating intermediate bodies and destroying the organic unity of the social body. This passage is also remarkable because it presages most of the attacks that were to be made later in the century against new works on account of their decadence. Hypertrophy and autonomization of detail, blurred vision: such were, for instance, Paul Bourget's complaints against the impressionists and Huysmans, or Nietzsche's against Wagner. But Baudelaire's attitude is not really clear: equality is inevitably ridiculed by art. In Baudelaire, the politician and the artist compete: once again, we don't really know where we are, but the popular reference is destined to be repudiated.

3. Meaninglessness or the loss of sense, which cannot after all be separated from the rejection of organic unity and totality. The nonfinished and the fragmentary meet in the indeterminacy of meaning: it no longer means anything. Let us recall the dedication of *Spleen de Paris:*

> "A small work of which it would be unfair to say that it has neither head nor tail, since on the contrary everything is both head

and tail, alternately and reciprocally . . . we can cut where we want . . . Take away a vertebra and the two parts of this tortuous fantasy will join together again without difficulty. Chop it into many pieces and you will see that each one can stand on its own.

The ancient ideal of harmonious composition modeled on the human body is thus ridiculed in favor of a grotesque image and a monstrous body. From Baudelaire's 1855 proposition, "the beautiful is always bizarre" until the final sentence of Breton's *Nadja*—"Beauty will be CONVULSIVE or it will not be at all," the reader or viewer is the one left to decide on a meaning if he can.

4. Autonomy, reflexivity, or circularity—for Baudelaire's definition of modernity by means of the dual nature of beauty requires from the artist a critical consciousness. Roland Barthes was later to give the name *autonymy* to this essential component of the modern tradition, which he defined as "the disconcerting squint of a circular process." Such is the condition of a modernity that no longer recognizes exteriority in relation to its art, neither code nor subject, and therefore sets up its own rules, models, and criteria. The modern work provides its own user's manual, and its manner is an embedding, or self-criticism and self-referentiality, which Mallarmé called the *pli,* the bent or orientation of the work, contrasting it with journalistic flatness. Since Baudelaire, poetic function and critical function have been inevitably woven into the artist's necessary self-consciousness about his art. Since Courbet's *L'Atelier,* to destroy the painting is to paint it, and the self-portrait is the modern genre par excellence.

With Baudelaire the basic and paradoxical features of the modern tradition are proclaimed, and he does this without bragging, since the poet saw them as an effect of the world's modernization, which he considered to be part of a decline, that is, a further progress toward the end of the world. As a result, even though Baudelaire chose David and Guys over Courbet

and Manet, he foresaw the main criticisms that would be made in future decades against an aesthetic modernity perceived as a decline and for which he would be held responsible. Except for a short period, Baudelaire was not among those who believed in progress: he was condemned to modernity. The deepest paradox of modernity is that the passion for the present with which it is identified should also be interpreted as a Calvary. The issue is not yet one of being snapped up by the new: "Imagine an artist who, spiritually, was always in a state of convalescence," writes Baudelaire, describing the modern artist. Or imagine a child: "The child sees everything as a *novelty*; he is always *drunk*." The later Nietzsche would also see convalescence or the "philosophy of the morning" as the only outcome of modernity that does not seek redemption through art or religion. Morning, convalescence, drunkenness, artificial paradise, but endless convalescence, childhood with no tomorrow. Baudelaire's modernity is always inseparable from decadence and despair.

Thus modernity must be clearly distinguished from the aesthetic of innovation and mania for disruption that was soon to be dominant. Though Baudelaire, insisting on the irrelevance of the past for perceiving the present, was among the promoters of the "superstition of the new," he bears no trace of this religion, no trace of an aesthetic of change for change's sake, of impulsive change, nor of what Valéry was to call "the new in itself." The dual nature of beauty with which modernity is identified implies that it should also be inevitably resistant to modernity. All Baudelaire's ideas are dual.

3

Manet was distressed by the outrage precipitated by his work. The first moderns wanted to please. The age had not yet come when the hostility shown an artist would be regarded as a sign of his future glory or, inversely, his early success as proof of mediocrity. Manet remained ambivalent toward modernity as he was toward the bourgeoisie: the militancy of the new was not

for him. When, after *Olympia,* he complained to Baudelaire of the attacks being made on him, the poet replied on May 11, 1865: "[Y]ou are merely the first in the decrepitude of your art." This ambiguous statement should be seen in conjunction with the equally ambiguous judgment he made in 1846 about Delacroix, "the latest representative of progress in art." By "decrepitude" Baudelaire most likely meant the reduction of painting to seeing, lack of imagination. As he said in 1859, "Day by day art diminishes in self-respect by kowtowing before external reality, and the painter becomes increasingly inclined to paint not what he dreams of but what he sees." We recall Turner's words, which were to become the article of faith of impressionism: "Paint what you see, not what you know." Baudelaire's limited understanding of Courbet and Manet was affected by his distrust of realism, seen as the reduction of painting to the visible. Could Baudelaire have imagined in Manet's bundle of asparagus the avenue that would lead to Yves Klein's monochromes? Seeing too many affinities between Baudelaire and Manet would therefore be anachronistic, unless the misunderstanding between the two artists was seen as a result of their common ambiguity regarding the new. For them the new was less a choice than a sentence, and in Manet more than anyone else we can observe the paradoxes of modernity in his relationship to the past, the new, and popular culture.

The two paintings of Manet's that set off a scandal were *Le Déjeuner sur l'herbe* and *Olympia.* As Pierre Daix has suggested, it is likely that Baudelaire—who could appreciate only the Spanish inspiration in Manet, still conceivable in terms of subject and picturesqueness—neither liked them very much nor understood them. With these two paintings, however, it became obvious that the reality to which Manet was attached was not that of themes but of painting. Not only did he have little interest in historical painting and felt that the meaning in a picture was to be found nowhere but in the picture itself, but the picture, even more than in Courbet, was brought to its surface

with neither perspective nor relief to create an illusion of depth. Both form and content contributed to the scandal, as they no doubt did to Baudelaire's lack of understanding.

Le Déjeuner sur l'herbe was displayed in 1863 at the Salon des Refusés, at the same time as Cabanel's *Naissance de Vénus,* a beautiful academic nude disguised as a mythological figure, which triumphed at the Salon before its purchase by Napoleon III and still triumphs today at the Musée d'Orsay, where it enjoys better lighting than the Manet. *Olympia,* which dates from the same year, provoked an even greater uproar when it was exhibited at the Salon of 1865. Why did these paintings meet with such hostility? Their subjects were seen as provocations. In each people saw the glorification of a prostitute or studio model, a feminine type generally associated with loose morals, as though the painting were poking fun at painting by exposing its conventions! *Le Déjeuner sur l'herbe* seemed like a joke: two naked women and two fully clothed men picnicking in a park. Even though this was not Manet's intention, the painting, like many modern works, was received this way. A nude in a modern-day setting, a realistic scene with no pretense to allegory, without any preestablished meaning: this was what shocked and disconcerted the public. And yet today, it is not so much the provocation that strikes the viewer as the classical models that inspired the painter. Manet's plan was to "redo a modern Giorgione," taking his inspiration from the *Concert champêtre* (now attributed to Titian) at the Louvre, and echoing the group of two rivers and a nymph on an engraving popular in artists' studios, after Raphael's *The Judgment of Paris.*

Formally, there is no integration of the picture's three components—the landscape in the background, the central group, and the still life in the foreground. The landscape is merely a painted sketch or stage scenery. The models are clearly assuming studio poses in awkward contrast to the background. The Japanese influence is evident: the human figures are outlined and stand out against a flat background, as in a tapestry. There

is a lack of unity between the figures and the landscape. And as for the subject itself, it is impossible to say whether the provocation is intentional. As for the still life, it bursts forth from the canvas like a piece of insolence owing to its precision and brilliance, with the rest of the scene simplified and colored in. Because of its academicism the still life accentuates the women's nakedness and makes them seem undressed rather than nude. Finally, the painting's composition indicates depth and perspective, while the figures and the background are treated flatly and without relief. The still life, like a wink or another joke, appears to be the picture's only element in keeping with academic credibility. It has been noted, however, that the still life is in fact nonrealistic, for the basket of fruit juxtaposes cherries and figs, which do not naturally exist together. As for the human figures, they seem as though isolated behind a pane of glass pierced only by the dark glance of Victorine, the model at the center of the picture, while the viewers are in front with the basket of fruit.

Today, the nude figure seems to us far less indecent or hypocritical than those of Cabanel or Bouguereau, two painters who were adulated during the Second Empire. But instead of presenting itself as an allegorical nude, it signals that it represents a model in repose. By exhibiting a studio model, who is singularly present in the middle of the picture, the painting appears to ridicule the academic tradition, which sought to have the model's reality disappear in a timeless symbolism. Here the contemporary world is flagrantly present: no one can doubt that Victorine will put her clothes back on as soon as she has finished posing. The trajectory of the picture reverses the usual transposition of academicism: Manet goes from the ideal to the real, from the mythical object to the actual model, rather than from the real to the ideal. Hence the sense of pastiche or tableau vivant, of parody and play—all this under the Second Empire, an era of both prostitution and the covering up of statues in public parks.

What is the meaning of this picture? What can it possibly be

saying? Everything suggests that Manet's intention was highly ambiguous. He wanted to produce a modern masterpiece by associating the painting of masters through simplified means. The blend of tradition and immediacy, of the culture of the elite and common references to the everyday, makes *Le Déjeuner sur l'herbe* an emblem of modernity, as would Picasso's *Les Demoiselles d'Avignon* later on. *Le Déjeuner sur l'herbe,* combining all the features that Baudelaire required of a modern work—including great innocence—marvelously illustrates the paradoxes of Baudelairean modernity: by its acceptance of the present, the present inevitably became new and iconoclastic. Even if Manet is seeking the present rather than the new, he still marks the beginning of a flight into the new that was to characterize all modern art. Is this the reason why Manet's painting has been parodied so often, in the same way it parodied the Italian Renaissance? The technical audacities and thematic insolence of this painting helped to make this the first modern painting, with all the imperfection this implies, and that *Olympia* was partly to resolve.

In the *Olympia,* the interplay of tradition and modernity is of the same order, but because it is better controlled, the resulting work is both ephemeral and timeless. Baudelaire wrote: "Woe to him who studies antiquity for anything besides pure art, logic and a general method! If he plunges too deeply inside it, he will lose all memory of the present." But the way in which Manet plays with the past is precisely what draws the "mysterious beauty" that makes modernity worthy of becoming antiquity. *Olympia* is the last of the great nudes in the history of painting; it is also a modern painting because of its subject and technique, and also because of the controversy it aroused: the black cat in the picture figures as a signature of modernity. At the start, two opposite readings of *Olympia* were offered. One, first voiced by Zola, was formalistic and disregarded the theme:

> For you a painting is strictly a pretext for analysis. You needed a female nude and you chose Olympia, the first woman to come along. You needed light and luminous patches, you put in a

bouquet. You needed dark patches and painted a black woman and a cat in a corner. What does all this mean? You don't know, and I don't either. But what I do know is that you have succeeded marvelously in creating a work by a real painter, a great painter.

The second reading, iconographic in nature, emphasizes the subject: a studio model once again aping the subjects of great paintings. Two of the sources are obvious: Titian's *Venus of Urbino* and Goya's *Maja desnuda*. The composition is that of the Titian: the bent right elbow and the left hand in the same pose as the *Venus Pudica* hiding her sex. But the transformations are blasphemous. In Titian's painting the nudity was innocent; the dog, symbol of ordinary, everyday fidelity, the servants, and the marriage chest completed an allegory of domestic virtue. In contrast, Olympia looks at us square in the eye. Right at the center of the composition, her hand is on her sex, and in relief, while the rest is flattened out, which brings attention to precisely what the hand is covering up. The cat in place of the dog seems an erotic allusion. Lastly, the black woman appears to be bringing a bouquet from a client.

Compared to Titian and Goya, Manet introduces venal, naturalistic, and romantic love into a tradition of the nude that, until Ingres and Couture, presupposed distance and convention. Idealized images give way to the realistic nude: it is Victorine again, recognizable by her short legs, small breasts, and square face with pointed chin. With no pretext of allegory or mythology, she is a prostitute awaiting a customer. As for the famous ribbon that highlights her nakedness, how much ink, from Valéry to Michel Leiris, has it set aflowing! For a final sarcastic detail, we can add the mules Olympia is wearing, thus becoming *Venus With a Cat*. The success of this painting can be measured by the number of copies and imitations it inspired: Cézanne, Picasso, and Matisse took the chance. And, like the *Le Déjeuner sur l'herbe,* it demonstrates the controversial and iconoclastic fate of modernity.

Manet's two masterpieces bring out magnificently a final paradox of Baudelairean modernity. As we saw earlier, the convention between this modernity and popular culture is two-faced. The division of criticism into formalism and iconography could also be a result of the ambiguous connection between Manet's painting and the contemporary world that, as Thomas Crow has observed, can be seen as simply tacked on to the models of great traditional painting. What is Olympia after all, but a courtesan in the same pose as the *Venus of Urbino?* Here, as in Baudelaire, modern everyday life serves to disrupt the artistic routine, but the goal does not seem to be the reconciliation of art and life. Modern life is a means toward art, rather than its end, the painting of modern life representing a necessary step toward the purification of painting. The iconographic interpretation might be seen thus to place the accent on the means, the formalistic interpretation on the end.

In a typical move, Mallarmé was to resolve this uncertainty in Manet by showing the potential evolution within it. In his 1876 article "The Impressionists and Edouard Manet," now extant only in English, he points out the fate of the duality in the connection between modernity and the present. The painter, he writes, started out by introducing Parisian life into his work as something eccentric and new. But this was a tactical, momentary choice. Mallarmé is glad that prostitutes and picnics on the grass later gave way to an autonomous and strict kind of painting, detached from society and the marketplace and formally exploiting the shift brought about by modern life into great painting. "I content myself with reflecting on the clear and durable mirror of painting," says his impressionist painter, who has recaptured painting for painting's sake after Manet's first impure attempts. The autonomy of art, temporarily in jeopardy, had been regained. From here on the modern tradition would regularly turn toward popular culture to renew art and purify it of its conventions; it would eventually consoli-

date the very autonomy on which it had initially claimed to be making war. This ambivalence in relation to the public—for the public is the heart of the matter in this wavering between mass and elite culture—would remain one of the insoluble paradoxes of modern tradition.

TWO

■
■
■ THE RELIGION OF THE FUTURE:
■ AVANT-GARDES AND
■ ORTHODOX NARRATIVES

Literature is headed toward itself, toward its
essence, which is its disappearance.
—Maurice Blanchot, *The Book to Come,* 1959

Courbet and Manet caused a scandal, like Flau-
bert and Baudelaire, who were prosecuted in 1857 for *Madame
Bovary* and *Les Fleurs du Mal;* but neither painter displays the
now-characteristic feature of modernity as the rhetoric of rup-
ture and the myth of an absolute beginning, the feature that
leads us to identify modernity with the militancy of the future:
the awareness of a historical role to play. The first moderns were
not seeking the new in a present that pointed toward the future
and carried within itself the law of its own disappearance, but
the present with its quality of being the present. This distinc-
tion is crucial. As I have said, they did not believe in the dogma
of progress, development, and overcoming. They counted nei-
ther on time nor on history for their getting even. Their hero-
ism was truly that of the present and not the future, for to them
utopianism and messianism were unknown concepts. They did
not think that today's art would necessarily be extinct tomor-
row; they did not negate yesterday's art; and their obliviousness
to history was not mixed with a desire to make a tabula rasa of
the past. Thus they did not condemn themselves to immediate
denial: the belief in progress also means, paradoxically, that pro-
gressivist art accepts that it is instantly perishable and soon to
decline.

In short, the first moderns did not see themselves as an avant-garde. Yet modernity and the avant-garde are all too often confused. No doubt both are paradoxical, but they do not run into the same dilemmas. The avant-garde is not just a more radical and dogmatic modernity. While modernity can be identified with a passion for the present, the avant-garde presupposes a historical awareness of the future and a desire to be ahead of one's time. Whereas the paradox of modernity has to do with its equivocal relation to modernization, that of the avant-garde concerns its awareness of history. Indeed there are two contradictory elements in any avant-garde: destruction and construction, negation and affirmation, nihilism and futurism. As a result of this antinomy, the affirmation of the avant-garde has often served to legitimate a desire for destruction, theoretical futurism being merely a pretext for polemics and subversion. Conversely, the call for nihilism has been a front for many a dogmatism. The avant-garde, substituting the pathos of the future for acceptance of the present, doubtless activates one of the latent paradoxes of modernity: its claim to self-sufficiency and self-affirmation inexorably leads it to self-destruction and self-negation.

Modernity and the avant-garde did not appear at the same time. At the end of the nineteenth century, when the historical awareness of time became widespread and the earliest modernity was no longer understood, modernity and decadence became synonymous, for endless renewal implies sudden obsolescence. From then on the transition from the new to the outdated would be instantaneous. This is the intolerable fate the avant-gardes created for themselves by presenting themselves as historical, taking the indefinite movement of the new for a critical overcoming of the past. In order to remain meaningful and distinguish itself from decadence, renewal must be identified with a course leading toward the essence of art, a reduction as well as a purification. "Poetry will no longer set the pace for action; it will be *ahead of it*," wrote Rimbaud in 1871. What

were the origins of this fateful rhetoric by which we identify modernity more as the religion of the future than as an identification with the present? For this rhetoric is not peculiar to the avant-gardes. As we shall see, they share it with the orthodox histories of the modern tradition. The result, which is also paradoxical, is that these histories know nothing of modernity.

I

I shall now return to the metaphorical meaning of the term *avant-garde* in the nineteenth century. In the strict sense it is a military term meaning the part of an army that marches ahead of the main body of troops. It later took on a political and eventually an aesthetic sense. Its political use became widespread during the revolution of 1848, as witnessed by the caricatural figure of Publicola Masson in Balzac's *Les Comédiens sans le savoir* (1846); at that time the term meant both the extreme left and extreme right, and could apply to both progressives and reactionaries. From there it passed into the vocabulary of art criticism. But during the Second Empire, between 1848 and 1870, its aesthetic extension underwent a major shift: avant-garde art went from being art for the sake of social progress to art that was aesthetically in advance of its time. This shift is comparable to the autonomization of art mentioned in connection with Manet: though avant-garde art before 1848 had this status because of its themes, after 1870 it became so because of its forms.

True, as early as the renaissance, Etienne Pasquier, in his *Recherches de la France,* labeled the poets Maurice Scève, Théodore de Bèze, and Jacques Peletier as "avant-garde" in relation to Joachim Bellay and Ronsard. Pasquier was in fact describing literary evolution as a progression, entitling one chapter of his book "On the Ancientness and Progress of our French Poetry," but neither *progress* nor *avant-garde* denote any awareness by these poets of their historical role. The use of these terms in a history of poetry would not have the same

implications without a doctrine of scientific, historical, and social development. In Pasquier, *progress* and *avant-garde* do not involve a belief in the meaning of history, and in the nineteenth century this metaphor was to take on quite a different meaning.

In the first sense of a socially committed art, we find the descriptive term *avant-garde* used by the Saint-Simonians to designate the mission of the artist together with that of the scholar, the scientist, and the industrialist: to serve as a front-runner for the social movement and a propagandist for social-ism, in the same way the Romantic poet saw himself as a prophet. According to a text by Saint-Simon in 1825: "Let us unite, says the Artist to his interlocutors, the Scholar and the Industrialist, and to reach the same goal we each have a different task to perform. It is we artists who will be your avant-garde: the power of the arts is indeed the most immediate and the quickest." The Fourierists also thought of art as a means of pro-paganda and a tool for action.

As has often been noted, however, this socialist or socially committed art was aesthetically the most academic and pedes-trian kind of all, according to a factor that has prevailed from the 1920s on, when the constructivist avant-garde in the Soviet Union fell into disfavor and socialist realism triumphed. In *Mon coeur mis à nu* Baudelaire was already taking on the "military metaphors" so beloved by the French, with their "militant school of literature," "their militant press," their *poètes de com-bat,* and "their literary vanguard." "This habit of military metaphors," he wrote, "is a sign of minds that are . . . made to be disciplined, that is to say, made to conform." Avant-garde art has never been the vanguard of art. This, moreover, is the true sense of the metaphor's shift in meaning after 1848 and the result of the hostility encountered by all innovative artists in the nineteenth century. Instead of enlisting in the service of revolu-tionary politics, avant-garde artists were betting on the revolu-tionary power of art itself, and Lautréamont's slogan, later echoed by the surrealists—"poetry will be created by all and not

by one"—indicated the end result of this evolution. Extending the vocabulary of politics to art, the avant-gardes seem to have always been divided between anarchy and authoritarianism, and Baudelaire early on spotted the dilemmas they would necessarily face: those of conformism and nonconformism.

As I said earlier, Courbet and Manet, Flaubert and Baudelaire, all wanted to belong to their own time. Although their work caused a scandal, they never attributed this to their being in advance of their contemporaries. They were in conflict with the conformism, for example, that pervaded the institutions and academies whose recognition they never ceased to long for: for Manet it was the official Salon, for Baudelaire the French Academy. This conflict was still conceived as being one between two aesthetic principles, realism and neoclassicism, and later between impressionism and academicism, but the impressionists themselves had no sense of being more advanced historically than their detractors. The first to set out deliberately to be avant-garde, that is, who saw their artistic efforts as constituting a politics of art, were the neo-impressionists, who happened to be politically left-wing. Their champion was Félix Fénéon, who coined the term *néo-impressionisme*. In his article on the eighth impressionist exhibition of 1886, where Seurat's *La Grande Jatte* was exhibited alongside works by Signac and Pissaro, he placed these few artists "in the avant-garde of impressionism" and referred in a footnote to a recent book in which Manet's friend Théodore Duret had collected the former's articles since 1870 under the provocative title *Critique d'avant-garde*. At the start avant-gardism belongs to both the critic and his subject, for it is the critical viewpoint integrated into artistic practice that gives the term *avant-garde* its meaning. Along with Signac and Seurat, the neo-impressionists considered themselves to be the avant-garde of impressionism, indeed saw themselves as revolutionaries in politics as well as in painting and believed that all their practices followed the same scientific theory. Thus in 1890 Charles Henry would go to instruct the working-class people of the

Faubourg Saint-Antoine on neo-impressionist theories on color.

We must therefore make a distinction between two avant-gardes, one political, the other aesthetic: artists at the service of the political revolution according to the theories of Fourier or Saint-Simon, or artists who were content with a plan for aesthetic revolution. Of these two avant-gardes, the former wished to use art to change the world and the latter wanted only to change art, figuring that the world would follow. Renato Poggioli, who contrasts the two avant-gardes in these terms, believes that they were joined, or made one, for only a brief period—after 1871 and the Paris Commune—starting with Rimbaud, the perfect realization of this alliance, and up to symbolism and naturalism. Less marked by anarchism and so less strictly political, the beginnings of neo-impressionism seem more significant. They coincide in fact with a time when the terms *avant-garde, modernity,* and *decadence* as applied to literature were nearly synonymous, as seen for example in the journal *Le Décadent,* founded in 1866. But when the journal's founder Anatole Baju decided to give decadentism an overtly political agenda and presented himself as a socialist candidate in the legislative elections of 1889, symbolism then took up the banner of anticonformism on a strictly literary plane, and "decadent" soon lost its revolutionary meaning.

Similarly, when Signac, in an 1891 article in the anarchist journal *La Révolte* and under the pseudonym of "fellow impressionist," published a political justification for Seurat's art, the meaning of "avant-garde" had clearly shifted in the direction of aesthetic formalism in spite of the author's revolutionary convictions. According to Signac the first neo-impressionist subjects were borrowed from urban life, industrial labor, and leisure scenes of the masses, offering evidence of the social conflict between workers and capitalists. The real innovation of the neo-impressionism, however, lies not in social analysis of the leisure scenes of the rich but in the formal aesthetics that was discovered through these themes. As Thomas Crow wrote, "the libera-

tion of the avant-garde's sensibility presents itself as an implicit example of revolutionary possibility, and the artist plays his most effective role by concentrating on the autonomous exigencies of his medium." The passage by Signac exemplifies the definition of an avant-gardist aesthetics, which claims to be revolutionary in itself rather than in the themes it touches upon and to attack the social structure through its own formal practice. From here on any formal pursuit will be considered revolutionary in essence.

In shifting from the military to the aesthetic, the term *avant-garde,* in its anticipatory sense, underwent a change of value from the spatial to the temporal. In this fundamental change we recognize the fulfillment of what Stendhal had proclaimed in 1823 and what Baudelaire had resisted by postulating an eternal quality of the beautiful alongside its ephemerality: from then on art would declare itself only in historical terms. After impressionism, the vocabulary of art criticism became strictly temporal. Art desperately clings to the future, no longer seeking to adhere to the present but to get a jump on it in order to inscribe itself in the future. A break is to be made not only with the past but also with the present, which must be made a tabula rasa if one is not to be superseded before one has even produced. Art is irrevocably linked to an evolutionary model, that of Hegelian philosophy or Darwinism, unable to distinguish between true superiority and the ability to survive and adapt.

From 1870 on, as a result of this evolutionary model, the success of an artist would become suspect: "At the beginning of their careers all the great creators have met with strong resistance—this is an absolute rule that allows for no exceptions," wrote Zola in his *Salon de 1879.* Duret thus relates the existence of progress in art and "the long persecution inflicted on the truly original and creative artists of this century." I shall not dwell on the myth of this equation of politics and aesthetics; the impressionists soon fetched higher prices than the academicians

and, while the press called them *communards,* their chief art dealer, Durand-Ruel, was a legitimist and publicly supported the Comte de Chambord's claim to the French throne. Noting that many innovative artists were political reactionaries, might we not also claim that politics has been inversely related to politics? Did Stendhal not state at the beginning of his *Salon de 1824,* "My opinions about painting are those of the extreme left," while carefully specifying that this was true *only* of his opinions about painting? As for his political views, he said they were "mostly left-center—like those of the vast majority." We should, however, guard against a simple reversal of terms. The two equations are also absurd and, like Baudelaire, we should keep both categories distinct.

The 1880s, with neo-impressionism in painting and decadentism, then symbolism and naturalism in literature, thus mark the fateful connection of art and time, art and history, the shift from the negation of tradition toward the tradition of negation, toward what could be called an academicism of innovation, which each successive avant-garde denounced before succumbing to it. On the other hand the shift in meaning of "avant-garde"—first in the service of progress and later futuristic for its own sake—corresponds, as the title of Duret's book illustrates, to the moment when formal innovation became the guiding principle of critical interpretation. Since then art historians have shared the same doctrine of progress and the dialectical evolution of forms as the avant-gardes. Like any orthodoxy, the ensuing orthodox narrative about the modern tradition has an element of wooden, formalized language: genetic historicism, examples of which we shall see further on, allows for the exorcism of the modern sense of time and the reconciliation of the avant-garde's contradictory impulses toward affirmation and negation, freedom and authority, nihilism and futurism. To avoid this avant-gardist dilemma amounts to reducing history to a tautology.

2

According to this new orthodoxy, the modern tradition that emerged toward the end of the nineteenth century is the story of art's purification, its reduction to its essence. It is in this sense that we often see the transition from one generation to the next and from one artist to another described as a progression on the road to truth, a stretching of art to its limits, or a reduction of illusion, a reappropriation of its origins. In order to pinpoint the beginnings of this formalism, critics willingly quote the saying by the painter Maurice Denis in 1890: "Remember that before it becomes a battle horse, a naked woman, or some anecdote or other, a painting is essentially a flat surface covered with colors in a certain assembled order." This is indeed a striking reminder that the preconditions for artistic authenticity were thereafter autonomy and self-referentiality.

It appears that this orthodox narrative of the modern tradition—shared, I repeat, by both the historical avant-gardes and the formalist critics—is based on an apologetical or teleological intention. Thus, in 1912 Apollinaire described the works of his cubist friends as "paintings in which the artist had tried to express the essential reality with great purity." At least since Mallarmé, the terms *purity* and *essence* are unavoidable in describing the autonomous adventure of art. According to Apollinaire, art always involves imitation, but henceforth what is imitated is the essential or conceptual, not the immediate and simple-minded appearance of things. The orthodox narrative always seems written with a view to its final outcome or denouement—which makes it teleological—and it serves to legitimate a contemporary art that seeks to break with tradition—which makes it apological or vindicatory. I shall offer two variations of this narrative of the modern tradition seen as a dialectic of purification. The first concerns poetry, which, in contrast to prose, is considered the true turf of literary modernity and features the gradual abandonment of traditional forms;

the second variation of this narrative involves painting. The orthodox narrative of the evolution of musical language would provide a similar example, going from the tonal to the serial system by eliminating conventions extraneous to the medium. In every case one presupposes an ever more extreme distancing from representation and reference—from what since Aristotle has been commonly called *mimesis*—in order to rediscover a more authentic foundation for art.

In poetry, language ceases to represent, or does so less and less, but instead is conceived as an autonomous game with respect to the reference. As an example of this type of history of poetry, I refer to a very well-known book by Hugo Friedrich, *Structures of Modern Poetry*, of which, since its publication in 1956, more than 160,000 copies have been sold in Germany and that has been highly influential in France as well. Friedrich explains poetry since Baudelaire, particularly its increasing obscurity and dissonance, as a loss of the representative function, which goes hand in hand with a depersonalization or loss of the self. Baudelaire, Rimbaud, and Mallarmé are three stages on the way to what Friedrich calls "ontological poetry." In Baudelaire, "poetry no longer springs from the unity established between poetry and the given man, as the romantics wanted it." Renouncing the expression of sentiment, poetry becomes deliberate, in other words, artificial:

> Dissonant beauty, the refusal to allow the "heart" to penetrate the essence of poetry, abnormal states of consciousness, empty ideality, distancing from the concrete character of things, secrecy, and mystery: everything arises from the magical powers of language, from the imaginary absolute. This beauty thus comes close to mathematical abstractions, to the movements and rhythms of music. It is with these elements that Baudelaire was able to create the possibilities that were to be fulfilled in the poetry that followed him.

It would be difficult to admit more openly the dialectical and evolutionist bias. With Rimbaud, on the basis of the "possibili-

ties" created by Baudelaire, such as the "achievement of Baudelaire's theoretical ventures," an additional step is taken toward derealization, notably in the *Illuminations:* the loss and disorientation of the reader. In a concomitant dislocation of language and subjectivity, the "I" also vanishes. "The *Illuminations* is a collection of texts that are not directed to any reader. They are storms of hallucinatory explosions." Destroying the world and the self, the work soon destroys itself and ends up in silence. Rimbaud's "silence" after the age of twenty-nine is a myth of modern art, somewhat like Kazimir Malevich's *White Square on White* of 1918. In Mallarmé, rarefaction and hermeticism are emphasized as a rejection of the limits of intelligibility and as a quest for *l'être en soi,* equivalent to the void, the empty transcendence of the *Coup de dés.* Platonism and Hegelianism seem to inspire this temptation of the Idea of silence.

> Mallarmé felt this proximity of the impossible to be the limit imposed on his entire work. The introductory sonnet to his collection of poems, *Salut,* refers to the three fundamental powers of his poetry and thought: solitude (the basic condition of the modern poet), the reef (on which he has run aground), and the star (the unreachable ideality responsible for this destiny). Moreover, Mallarmé admitted in a conversation: "My work is a dead end." His isolation is absolute and deliberate. Like Rimbaud but in a different way, he leads his poetry to the point where it destroys itself and announces the end of all poetry. Strangely, this process was to repeat itself throughout twentieth-century poetry: it must therefore correspond to a profound trend of modern times.

Mallarmé's endpoint is *Le Livre,* an empty, impersonal, and absolute form of which there remain only rough drafts.

This fine historical-genetic explication of modern poetry, juggling theory and analysis, is so attractive, so marvelously clear and simple in its description of obscurity itself, that it gives one pause to express any reservations lest they might be

misunderstood. Having made the decision nonetheless to raise a few objections, I borrow the first ones from Paul de Man's *Blindness and Insight*.

In order to justify the coexistence of derealization and depersonalization (the two factors in the dialectical analysis of the modern poetic tradition), we need to refer—and Friedrich here is merely the representative of a vast chorus of critics—to the crudest kind of sociological generalization on the "historical situation of the modern mind"; the poet flees a reality that has become increasingly unpleasant since the mid-nineteenth century. Indeed, Mallarmé wrote: "The poet's attitude in an age such as this, when he must be on strike vis-à-vis society, is to set aside all the tainted means that may present themselves to him." But from there it is an abrupt leap to claim that the entire history of the poem, moving toward its autonomy and ontology, can be simply summed up as an evasion or side-stepping of the issue in the face of the social reality of today. De Man rightly argues that through this interpretation Friedrich's genetic narrative—whose central element and parameter is the growing obscurity of modern poetry—reveals itself as an implicit process in poetry seen as decadence and negativity, or evasion. Between praise and blame, there is after all only a difference of signs, and the same process can end up describing the poetic movement toward truth or toward nothingness.

More important, De Man challenges the so-called disappearance of the object in Mallarmé in favor of a strictly intellectual and allegorical logic, the objects being "amputated of their very objecthood," thus, according to Friedrich, *vases, console tables, fans, mirrors, clouds,* and *stars.* In the verse, "This immaterial mourning burdens with myriad nubile folds star ripened ripened by tomorrows," the words, according to De Man, also carry levels of meanings that remain representational and symbolic, in other words, preestablished meanings. Mallarmé's poems all mean something. They are all translatable, as it were, even the most hermetic, "Her pure nails offering their onyx on

high," and do not fit Valéry's formula "My verses have the meaning anyone may give them." In short Mallarmé's poetry is no less representative than Baudelaire's and no more indeterminate or undecidable in meaning. We should not confuse obscurity and modernity, hermeticism and absence of reference.

Furthermore, the orthodox narrative of the modern tradition as the quest for essence paradoxically overlooks an essential component of modernity: *irony*. Thus, in the sequence of Baudelaire, Rimbaud, and Mallarmé, the absence of Lautréamont is conspicuous, for he was later to become a beacon of modernity, or at least one variant of it that passes on to Marcel Duchamp and André Breton, whereas since Valéry, history seen as purification has been written retrospectively as a denouement. It is the endpoint that dictates the scheme's parameters. But this irony, unrecognized in the historical-genetic scheme, was masterly in Baudelaire who in "De l'essence du rire" proposed a definition of it as the result, once again, of "a permanent duality in the human being—that is, the power of being oneself and someone else at one and the same time." The orthodox narrative, however, privileges the tragic or Mallarméan side of the critical stance at the expense of Baudelairean irony and melancholy; in Baudelaire it chooses the features most likely to make him a starting point, and thus privileges one aspect of Baudelaire at the expense of another. In the true Baudelairean modernity, the duality is nonetheless essential, a duality of the beautiful and a duality of man, marked by the influence of Joseph de Maistre and nothing less than progressivist.

The last and most serious criticism is that the orthodox narrative, in making the new both an origin and a result—in De Man's words, "integrating the past as an active presence in the future"—seems to completely contradict Baudelaire, for it reconciles modernity and history and even sees modernity as the motor of history. Baudelairean modernity rejected history in its dialogue with eternity, and modernity tamed by the orthodox narrative is nothing more than the historical malaise that

Nietzsche called decadence. Whereas time for Baudelaire presented itself as a succession of disjointed presents, an intermittent time—at any rate if the artist wanted to bring out of it some kind of beauty—time for the avant-gardes confuses consecutiveness and consequence in the idea of getting a jump on the future. The orthodox narrative, like the avant-garde whose consciousness of time it confirms, sets up its misconception of modernity. A clear sign of this is the little store that Rimbaud and Mallarmé as well as Friedrich set by the *Spleen de Paris.* When Rimbaud criticizes Baudelaire for his attachment to the past, he has in mind the *Fleurs du Mal,* not the prose poems, in other words, what is most distinctively modern, allegorical, and nonrepresentational in Baudelaire. Thus the genesis of the movement from Baudelaire to modern poetry, such as Friedrich describes it, is not necessarily progressive from the viewpoint of a poetics of nonrepresentation. Far from going beyond the prose poems, all of modern poetry could actually be betraying Baudelaire.

This hypothesis is consistent, moreover, with that of Walter Benjamin in the essay "Theses on the Philosophy of History" in his *Illuminations* where he called for a history "against the grain," in contrast to a canonical history based on the idea of progress—that is, with the usual confusion—based on a succession of conquering heroes whose inevitability needs to be explained. The real question, as with Benjamin, is whether the true history of modernity is not really that of the works left behind by evolution, the losers, the ideas that ended in nothing (or at least nothing so far), the suspended origins, the failures of progress. Proust thus lamented that the work of Gérard de Nerval, reevaluated as part of the history of literature but as "a belated eighteenth-century writer," should be "admired today through what I take to be such misrepresentations that I would almost prefer the oblivion to which Sainte-Beuve consigned him." What then would be the history of that which has had no descendants, the history of the nonreception of art and litera-

ture? What would be the history of the failures in history? Perhaps it would be the history of the negation of the tradition that does not become institutionalized as a tradition of negation, something like the history of irony or melancholy. The tradition of negation sets some values against other values; the negation of tradition, however, is the hopeless irony and melancholy of Poe or Baudelaire.

The dialectical model, however, is still so powerful that De Man himself, one of the rare critics to inveigh against historical consciousness as a myth and against progressive time as an illusion, expresses reservations about Blanchot's overly ontological vision of Mallarmé's late works, which blinds him to see the temporal development still contained in *Igitur* and *Le Livre*. Faithful to the orthodox narrative, Blanchot describes a progression in Mallarmé from the particular to the universal, toward the reduction of poetry to the medium: an impersonal, autonomous, and absolute language identified with a consciousness without a subject. He sees the dialectics finally coming to an end in the endless rehashing of the same tired themes in *Le Livre*. De Man, who also sees in the dialectic a denial of the very negativity of being, nonetheless judges that the circularity and repetition Mallarmé ends with—"the inferior lapping of any kind"—do not rule out a certain form of development. Blanchot suggests this, moreover, though he does not make it explicit: "What we write is necessarily the same, and the coming into being of what is the same is, in its renewal, of an infinite richness." In short, there does exist a beyond in Mallarmé's ontology, dimly perceived by Blanchot and revealed by De Man: it is Heidegger and the end of metaphysics considered as leading to hermeneutics. The end still rules the narrative: but if De Man showed such perspicacity in correcting Friedrich, is it not because he saw the coming into being of modern poetry in terms of Heidegger?

Though Baudelaire was the father of modernity, it is quite uncertain whether his intellectual offspring "worked out all the

possibilities" of the *Spleen de Paris*. On the contrary, his descendants were often unaware of what Baudelaire's modernity consisted in. Consider the example of the modern tradition's attachment to salvation through art, which is held to redeem life and experience: Mallarmé is permeated with this idea; it lasts all through the decadent movement; Oscar Wilde turns it into a religion; the products of it, in Proust and Joyce, still remain a monument; not until Samuel Beckett did modernity entirely give up on it, and this is why he is seen nowadays as a harbinger of postmodernity. And yet only a simplistic reading of "Spleen et Idéal" can mask the fact that Baudelaire, less marked by Schopenhauer than were the fin de siècle poets, had profoundly shaken up this doctrine. Baudelaire was not of the avant-garde; the avant-gardes who succeeded him repudiated him as much as they claimed to be his descendants. Like them, the advocates of the historical-genetic narrative of modern poetry, including Valéry on occasion, misunderstood Baudelaire's modernity: "It is wonderful to see someone as original as Poe drive lucidity so far, turning rigor almost against itself, to the point of attacking the idol of originality. He would not like Baudelaire have considered the new as having a value in itself." Here again, this is to see Baudelaire as a contemporary of Breton's and a fellow traveler of surrealism, a fanatic of the new. Even a writer as skeptical of progress as Valéry can be seen here to be reading history in the sense of a smooth advance.

3

For a second variation on genetic historicism, I shall cite Clement Greenberg, the most influential post–World War II American critic, who proposed a general theory of modernism to account for the evolution of painting from Manet to abstract expressionism, particularly Jackson Pollock. Greenberg was a contributor to the major New York art journals from the 1930s on, and his 1961 collection of articles, *Art and Culture,* is still

widely used as an introduction to contemporary art for American college students. Because I shall later be discussing American painting after 1945, I merely indicate here that according to Greenberg's account, action painting, dripping, or painting without an easel, which represent the ultimate stage in painting, are seen as the denouement in terms of which the story is told and give the plot its teleological character: "The essence of modernism is to use the specific methods of a discipline to criticize that very discipline, not for the purpose of subversion, but to insert it more deeply in its area of *competence*." Greenberg thus sees modern art as based on the idea of self-criticism: starting in the middle of the nineteenth century, painting became a critique of painting in which it established the limits of its own language. Greenberg makes a clear contrast between self-referentiality and simple transgression or negation, which thus confirms the formalism of this viewpoint.

In all honesty, it should also be admitted that in his best-known article, "Avant-garde and Kitsch," Greenberg was already defending the same kind of formalistic narrative even before the war and hence before Jackson Pollock's work: "It is in search of the absolute that the avant-garde has arrived at 'abstract' or 'nonobjective' art—and poetry too. . . . Content is to be dissolved so completely into form that the work of art or literature cannot be reduced in whole or in part to anything not itself." The philosophical tradition that begins with Kant's critiques and continues through Hegel's aesthetics, ends with Greenberg as well as Theodor Adorno, both partisans of a history of style as an internal phenomenon, and both opposed to the Marxist vulgate of a sociological explanation of art. Thus, in a passage closely related to Greenberg, Adorno wrote:

> When painting and sculpture free themselves of any resemblance to the object, or music from tonality, the essential reason is the need to give the work, starting with itself, a little of that objectivity it lacks as no more than a subjective reaction to any

fact. The more the work of art critically rids itself of all condi-
tions not immanent in its own form, the more closely it thereby
approximates a heightened objectivity.

The purpose of the critique is to reduce each art to the unique
and essential elements in its particular medium, to recapture its
authentic foundation, in order to eliminate the features bor-
rowed from other artistic mediums along with the conventions
unessential to a given medium. In an important 1955 article
"American-Type Painting," Greenberg confirmed this principle:
"It seems to be a law of modernism—thus one that applies to
almost all art that remains truly alive in our time—that the con-
ventions not essential to the viability of a medium be discarded
as soon as they are recognized. The process of self-purification
appears to have come to a halt in literature simply because the
latter has fewer conventions to eliminate before arriving at those
essential to it."

Since music, according to Greenberg, has also easily elimi-
nated its superfluous conventions, only "painting continues,
then, to work out its modernism with unchecked momentum
because it still has a relatively long way to go before being
reduced to its viable essence." The history of modern art is thus
told as the quest for the degree zero and absolute purity. In the
case of painting, whose medium is the surface, development has
proceeded in the direction of flattening; the juxtaposition of
facet-planes in contrast to the superposition of layers. The
heroic principle of modernism consists in pushing ever farther
the Pillars of Hercules, and what Greenberg calls "flatness" was
the truth of painting. Like Friedrich with poetry, Greenberg sees
purity and essence as the ruling categories of the orthodox nar-
rative in painting.

One of modernism's most eloquent theorists, Greenberg, has in
the last few years ago become the bête noire of the proponents
of postmodernism. In endorsing transgression, heterogeneity,
and eclecticism, the postmodernists' attacks have singled out

Greenberg's unidirectional narrative on the grounds that it privileges painting's mainstream. The reservations I have will also focus on the powerful blows such a narrative inflicts on the history of painting. Thus, before taking on the tautological character—teleological and apologetic—of this narrative, I should explain how my view differs from postmodernism. Even though it is genetic, the explanation of painting by painting seems to me preferable to the explanation of poetry as a flight from reality: they are not the same thing, and the quest for the truth of the medium is not necessarily to be identified with a closing off of the rest of the world. The formal genesis of modernism proposed by Greenberg is certainly more satisfying than the current view of the seeming antirealism of modern painting, which attempts to explain modern painting as a search for a higher realism than ordinary realism, or as the expression of a concern for a greater fidelity to experience and perception—in short, as the quest for a *supplement* to reality.

Thus, since Apollinaire and particularly Daniel-Henry Kahnweiler, the progression from realism to impressionism, neo-impressionism, and cubism is most commonly described as a movement toward authenticity, through the suppression of artifice and the redemption of classical painting, which has been seen as "lying" ever since the triumph of geometrical perspective in the Renaissance and the victory of drawing over color. Depth is not seen but is constructed mentally, and perspective represents a visual deception. But, according to an argument that paradoxically seeks to make new painting accessible in the same terms as the art it claims to be replacing, the type of painting that gradually deprives space of *relief* is still offered as an imitation—if not imitation of what one knows, then at least of what one sees. One is reminded of the anecdote about Courbet, who painted a color on a canvas without knowing what it was the color *of,* then sent someone out to see what it was (a bundle of sticks). The color was correct, or true, because the painter did not know what object he was painting. From impressionism,

with its three principles—natural color, the division of colors, and optical blending—to pointillism, which not only separates the hues on the palette but also isolates the brush strokes on the canvas, the movement can be seen as epistemological and is based on a science of color that allows for greater fidelity to the real. In the movement between knowing and seeing, from Ingres to Seurat and Braque, I might even add—were the terms not already taken—that antirealism could also be considered a kind of surrealism or hyperrealism—in short, a higher realism. The same goes for the movement between knowing and feeling, according to a definition of expressionism as the representation of emotion and reaction rather than of impression.

In these analyses the surreptitious return to representation is remarkable, as though the viewer wanted at any cost for what he sees to correspond to something real and anthropomorphic, to really mean something. This was the case until cubism, where the reality in question was seen as having become psychological: "the art of painting new compositions with formal elements borrowed not from visual but conceptual reality," wrote Apollinaire. This explanation, which turns the strange into something routine and even banal, is all too familiar: on the cubist canvas, the subject is seen from all sides at once, including what is inside and hidden from view. In connection with Picasso's portrait of him, Apollinaire seems to have been the one responsible for this commonplace, reducing the cubist canvas to the "unfolding of the geometrical surface." This really amounts to claiming—no doubt in defense of cubism but also betraying it through oversimplification—that this vision corresponds to the truth of a conception or of a phenomenological perception, for we are still aware of the existence of the hidden part of the objects we see. This is the very thing that makes us accept the illusion of perspective, which represents distance and depth by means of height and width. We do indeed rebuild the visible world with mental constructs. Nonetheless, cubism is not a

phenomenology of representation nor is it an application of non-Euclidian geometries.

The interesting aspect of Greenberg's analysis thus appears to be his refusal to accept the view of impressionism or cubism as explicable through a higher realism or through the discovery of a new world to paint, and the fact that he confines himself to painting as painting only, finding ways to force a reading of painting as a surface. So what are the objections to this? They can be summed up by invoking the name of the greatest painter in the modern tradition, the crossroads of impressionism, expressionism, and cubism: Cézanne, misunderstood ever since his childhood friend Zola had him kill himself at the end of *L'Oeuvre,* the story in which the novelist dramatized what he considered the painter's failure, and as a result of which the two men had a falling out.

Like Baudelaire, Cézanne cannot be assimilated to an orthodox narrative grounded in genetic historicism. He occupies a highly paradoxical niche in a history of painting conceived as the conquest of flatness, in which he could fit only at the expense of disregarding his distinctive modernity and true originality. Cézanne indeed reacts against the flattening of painting that resulted from impressionism and even more from neo-impressionism, as for example in Seurat's *La Grande Jatte,* where the human figures are reduced to cardboard silhouettes. Pointillism was able to create an illusion of depth, but not of volume in the space of this depth. Cézanne's ambition, far from going into further explorations of flatness, was to delve once again into impressionist space—"to redo Poussin after nature," he said—and thereby to reconcile impressionism with the great tradition of the masters. Like Manet, he had no wish to do battle with the masters or eliminate them. In his mature work he substitutes variations in the planes of solids for the impressionists' variations of light and relief by means of warm and cool

tones instead of the traditional contrast of light and shade. Such are the essential features of the synthesis he attempted to create between modernity and tradition, aiming to recover a sculptural unity in painting after impressionism, a project that does not fit into the narrative of the flattening of painting. Greenberg himself, in an article on Cézanne written in 1951, mentions a perpetual oscillation between the literal surface of the painting and the "content" behind it. Cézanne is the only example since Manet of a painter who respects both depth and surface, combining trompe l'oeil with the laws of the medium. Nonetheless, in order to set Cézanne on the right path, Greenberg's tactic, after acknowledging the painter's wish to create a sculptural impressionism, is to emphasize that this was only a means toward an end that later proved true to the orthodox narrative. In his view Cézanne was mistaken about his work: "Cézanne's effort to turn impressionism toward the sculptural was shifted, in its fulfillment, from the structure of the pictorial illusion to the configuration of the picture itself as an object, as a flat surface. Cézanne got "solidity" all right, but it is as much a two-dimensional, literal solidity as a representational one." The painting, the movement of the painting itself, betrayed the painter who disliked the flat pictures of Gauguin and van Gogh, yet through the "possibilities" his successors found in him, contributed toward an even greater flattening of painting.

Greenberg writes that Cézanne's ideas about his own painting were somewhat confused. From a formalistic viewpoint that stresses self-criticism and theoretical awareness, this should diminish our evaluation of the artist. Despite some ambiguous statements about Cézanne's "brio" that betray his reservations, Greenberg still maintains—in contradiction to his history of the modern tradition—that Cézanne, who struggled unremittingly against the flattening of painting, was the greatest modern master because of his role in the conquest of flatness.

Correct in its details, but forced in its objective, Greenberg's view of Cézanne is biased because it is historical-genetic. The

critic tries to above all account for the fact that "the path that Cézanne had chosen to follow . . . led straight, within five or six years after his death, to a kind of painting as flat as any the West had seen since the Middle Ages." Cubism is the necessary denouement on the basis of which Cézanne is re-viewed and misunderstood, in spite of all the praise: "The Cubism of Picasso, Braque, and Léger completed what Cézanne had begun." Here at last is the admission that decrees the reduction to which Cézanne has fallen victim. Nevertheless, it could be shown that during the next stage, from 1910 to 1914, which were years of cardinal importance in art history, Greenberg's narrative assumes a similar reduction of cubism to the general scheme. Thus, from one reduction to another, we come easily to the work of Jackson Pollock.

Let us take the case of Braque, which is simpler than that of Picasso. In 1906 to 1907 he painted brightly colored fauvist landscapes such as his *Houses in Estaque,* which in 1907 gave rise to the term *cubism.* Then in 1908 he painted landscapes of the South of France—pine trees, plain houses. This so-called analytic phase of cubism is marked, as in Cézanne, by the quest for sculptural effects through nonsculptural means. The result, however, is an increasing abstraction in the face of which, in Greenberg's narrative, Braque sought by various means to play between the literal surface of the picture and the representation, finally giving way to flatness. Around 1911 flatness invaded the cubist painting; the facet-planes to which the visible is reduced, as though by dissection, are all parallel to the plane of the picture. Each facet, shaded as a unity in itself, is without connection or gradation in relation to those close by. The represented flatness and the literal flatness merge. And yet, in 1910 Braque had attempted to reintroduce the illusion of depth through a conventional trompe l'oeil: a nail or piece of rope projecting its shadow. According to Greenberg, however, the intruding object had the effect of undeceiving the viewer's eye and asserting the painting's surface. Printed characters, sand, pieces of paper

Paul Cézanne. *La Montagne Sainte-Victoire.*
THE ART INSTITUTE OF CHICAGO.

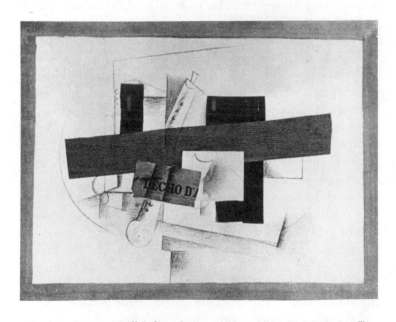

Georges Braque. *Still Life with Tenora* (formerly called "Clarinet").
(Summer or fall 1913.) Pasted paper, oil, charcoal, chalk, and pencil
on canvas, 37 $\frac{1}{2}$ x 47 $\frac{3}{8}$″. COLLECTION, THE MUSEUM OF MODERN ART,
NEW YORK. NELSON A. ROCKEFELLER BEQUEST.

maintained the oscillation between surface and thickness. Through its absolute frontality, the typography brings everything else in the painting into play as reminders of deep or plastic space. Braque also imitated wood, then tapestry braids that, in 1912, led to a crucial gesture in the history of painting: the gluing or *collage* of foreign matter onto the canvas. Like typography, the collage by its stronger presence brings everything else into a clearer idea of depth. This too, according to Greenberg, is a method for proclaiming the surface and, as a result, the literal flatness stands out as the chief element, also pinpointing the date of the shift from analytic to synthetic cubism.

This in any case is how Greenberg rather unsubtly accounts for the transition to cubism. All the heterogeneous elements in this process are brought back to the essential point: the conquest of flatness. Once their historical role is played out, these elements immediately vanish. Isolated from its context, the collage becomes a strictly formal procedure. Playing dialectically between the plane surface and the sculptural effect, it makes possible an intellectual and abstract treatment of the problem of representation. The bits of glued paper have lost all trace of their original medium. Once they have been placed in the collage, the fragments retain nothing of the original reality to which they belonged or of any prior meaning through which the meaning of the collage itself might be reconstructed. They are pure entities that make it possible to formulate the problem of representation; they are theorems or axioms. Greenberg's canonical narrative, while acknowledging Cézanne's greatness in contradiction to his own principles but failing to recognize the problem left unsolved by Cézanne—to wit, the search for a possible space for painting after impressionism—also fails to understand the reality of the collage. The means is overlooked in favor of a postulated end. And what is overlooked each time is the presence of the modern tradition in the world. Is it against its presence in the world, in the pictures of Cézanne or the collages of Braque and Picasso, that the modern tradition took form?

The formalist narrative allows us to think so. Meager, incomplete, heterogeneous, anonymous, deep or thick—the glued bits of paper of Braque and Picasso in 1912 to 1913 may seem of little matter, but of the kind that blazes the path of the history of painting: like Walter Benjamin, one is tempted to write the story of these odds and ends. Admittedly, it did not take long for Cézanne's space to be flattened out or for the collages to become abstract, but the wish they expressed was to return, and the speeded-up evolution following Cézanne's death may have eliminated, or denied, the question asked by Cézanne rather than resolved it.

This is why it is tempting to present Baudelaire and Cézanne, who after all were not progressivists, as the spoilsports who kept genetic historicism from going in circles. Greenberg is forced to recognize this: "The Cubists inherited Cézanne's problem"—meaning how does one go from one object to another, behind or beside it, without violating either the integrity of the painted surface or the three-dimensional representation—"and solved it, but—as Marx would say—only by destroying it. Deliberately or not, they sacrificed the integrity of the object to that of the plane surface." The progressivist vision thus leads to the writing of the history of those who have conquered: the story of the modern tradition as a modern betrayal. If we think of Baudelaire and Cézanne and their so-called "overcoming," the narrative that conceives modernity as a continuous historical process ignores the most essential aspect of modernity, that is, that which leads to nothing. "As far as I am concerned," Breton wrote in 1922, "I couldn't care less about Cézanne and, in spite of all his panegyrists, I have always considered his human attitude and artistic ambition to be absolutely moronic." This is what the religion of the future leads to. Let us thus dismiss both genetic historicism and aesthetic militantism as the two sides of the coin of the same illusion of progressivity.

THREE

■
■
■ **THEORY AND TERROR:**
■ **ABSTRACTION AND SURREALISM**
■

In our societies that are always on the move, delays
sometimes give us a head start.
—Jean-Paul Sartre, *Les Mots,* 1964

After the prestige of the new and the enthusiasm
for futurism, both of which emerged separately, another feature,
also contradictory, is also associated with the modern tradition:
its theoretical terrorism. Thus, in Greenberg's orthodox narra-
tive, Cézanne, consistent with the avant-gardes' historical
awareness, is put in his place on the grounds of his theoretical
inadequacy. This example alone illustrates the paradoxical role
assigned to theory in the modern tradition: artists such as
Cézanne who would mark art history deeply based their work
on theories we now judge tenuous or false while the most
unshakable theoretical programs and the most assertive avant-
gardist manifestos produced only works that were soon to be
forgotten, or picturesque anecdotes and memories. In the twen-
tieth century the correspondence between theory and practice
has often been dubious. As we have seen, the first moderns,
such as Baudelaire, Manet, or even Cézanne, were modern
despite themselves or without realizing it; they did not think of
themselves as revolutionaries or theorists. Manet wanted to redo
Giorgione, Cézanne wanted to redo Poussin; their slogan was
"redo," not "make new." But by the beginning of this century,
after a few generations had passed, the critical awareness
Baudelaire required of the artist as a hero of modern life became
a speculative or theoretical prerequisite. In truth, the relation

between formal intention and actual novelty is not self-evident, for art tends to overwhelm the best intentions in the world. Is art such a paltry thing that we believe it can be subjected to ideas, a philosophy, a politics, or a system? I shall take two parallel examples—the beginnings of abstract art and of surrealism—to illustrate the meeting, perhaps the antinomy of theory and practice, and the triumph of the latter over the former, then that of the former over the latter. But first let us see how the theoretical claim of modern art links up with the demand for the new.

I

From a historical viewpoint, we have seen some utility in distinguishing the values of the new from those of the future, since we thus make an aesthetic and philosophical separation between two notions that are often confused: modernity and the avant-garde. In truth, these two concepts presuppose two different awarenesses of time: a sense of the present as such and a sense of the present as a contribution to the future, an intermittent or serial temporality and a genetic or dialectical temporality. When modernity and avant-garde are reduced to a single criterion, the one that wins out, as in the case of most standard narratives, is the quest for originality. The struggle against conformism and convention, the crusade of creativity against cliché can then be considered to have begun in the mid-nineteenth century; they were later radicalized and accelerated—especially among the historical avant-gardes—in the early twentieth century. Futurism and Dadaism, surrealism and constructivism represent only a more exalted modernity, the emphasis constituting yet another form of development.

When we seek to reduce modernity and the avant-garde to a single definition and insist on merging them in a single movement, the motivation, I think, is political or ideological. The homogeneous description of the modern tradition as a cult of the bizarre or the obscure is an expression of the desire to iden-

tify the whole of modern art with a reaction against the uni-
formization of art and the industrialization of culture in a capi-
talistic society. Since the early nineteenth century, when the
romantics challenged the initial elements of mass culture and
artists began denouncing the degradation of bourgeois art as a
mercantile commodity, it would appear that the development of
an autonomous elite culture, opposed to the mass culture that is
subject to the requirements of social reproduction, has formed
the principle of the modern tradition, mingling all the different
tendencies and moving away from the masses in a search for the
formal.

In this, some of us may recognize a Marxist view of the world
and of art, as can be seen for example, in the Hungarian writer
Georg Lukács. The quest for the new would then be a distinc-
tive feature of modern art, in its autonomization relative to the
industrialization of the culture. But the requirement of newness
or novelty is also that of the capitalist market. The criterion of
modern art thus seems comparable to that of the market, for the
work of art is also a piece of merchandise. The artist, who rebels
against the bourgeois, depends on the same mode of produc-
tion, and we do not see that there can be any hope for him or
for art to avoid capitalistic alienation. Putting aside vulgar
Marxism, can we not still perceive two types of the new: the
false new that is only a fabricated appearance trying to pass for
the new in order to attract the customer, and the truly new,
which is that of art? Can we not make a distinction between the
new as an exchange value and the new as a conventional value?
In this case all modern art would be seen as rebelling less against
convention than against false mercantile novelty, against the
continual capitalistic discrediting of the new. The conflict thus
focuses on the art market itself, between true art and kitsch—if
we wish to lump together under this term all the cheap and ugly
pastiches that filled so many bourgeois living rooms, such as the
Barbedienne-style bronzes in the nineteenth century.

I have just summed up Theodor Adorno's subtle thesis,

expounded mainly in his 1970 *Aesthetic Theory,* in which the new, having been recognized as ambivalent, is seen as the dialectical principle of modern art. Because bourgeois society sees itself as a nontraditional society, the modern negation of tradition and the aesthetic authority of the new are historically unavoidable. The new is therefore less a repudiation of earlier practices than it is of tradition as such. Thus, according to Adorno, "to that extent it ratifies the bourgeois principle in art." The role of the new in modern art is seen as both a result of the domination of the new in the market in general and a resistance to the laws of the market. While vulgar Marxism situated the entire modern tradition on the side of bourgeois modernity, as merely a bohemian nonconformism and a tendency toward art for art's sake, Adorno's analysis places it entirely on the side of the avant-garde, as a challenge to the very institution of art. The question, however, remains: how can we recognize the genuinely new as opposed to the mercantile new that only appears to be new? Under the heading of the new, is not Adorno confusing the creative variation of mere surprise within the limits of a genre or style and the subversive, revolutionary negation of tradition itself? The category of the new does not allow for the distinction between what might appear to be new—though in reality subject to the dominance of exchange in capitalistic society—and what is historically and necessarily new. The protest thus comes from the adherents of the historical avant-gardes who do not want to see art for art's sake assimilated to the avant-gardes.

One of the sharpest critics of Adorno's category of the new is Peter Bürger in his *Theory of the Avant-garde* of 1974. He denounces a confusion that makes "the unique historical break defined by the historical avant-gardes [at the start of the twentieth century] the principle of the development of modern art as such." Here one is at a loss. Either the new is simply nonconformism, in which case the whole modern tradition is reduced to an autonomy of art as described by classical Marxism and that

has continuously evolved since around 1848, or the new is a radical negation of the institution of art and all modern art is conceived on the model of the historical avant-gardes of the twentieth century. According to Bürger, art began detaching itself from society in the eighteenth century and this autonomy kept on intensifying until the early twentieth century. The real turning point came then with the understanding by the avant-gardes of the function of art in bourgeois society and with their rejection of its autonomy. While all earlier movements had accepted this autonomy the avant-gardes created a radical difference by challenging the concept of the work of art. The avant-garde is not the negation of models, genres, or techniques, but of the very institution of art and its marketing in bourgeois society.

Without sharing Bürger's bias in favor of the historical avant-gardes, whom he exalts to the detriment of nineteenth-century bourgeois modernism, or subscribing to his proposed periodization to separate them at the start of the twentieth century, we must grant the legitimacy of his insistence that the new is an inadequate criterion for the whole modern tradition. A similar doubt has led me to distinguish between the middle of the century (when modernism first appeared) and the end of the century (when futurism appeared), between the sense of the present and the sense of the future. But Bürger wants more: he would like to find a criterion for more surely recognizing fashion and the modern, mere everyday novelty and historical newness. He in turn reproduces the very illusion of the historical avant-gardes by "justifying" the theoretical terrorism that assures them of their historical necessity. For the function of theory is ad hoc. Adorno wrote, "The truth of the New, the truth of the unviolated, is found in the absence of intention. It thus comes into contradiction with reflection, the motor of the New." The new is untenable. Under its authority, in what Adorno called the "cultural industries," art has lost its self-evidence. Theory claims to give it back: with theory inscribing art in a developmental scheme, art would regain its hold over the

duration that is supplanted by the new. The new is always close to death, as at the end of the *Fleurs du Mal.* Is not the point of Bürger's proposed questioning of the new, in Adorno's sense, to protect himself from its ambivalence.

Adorno's dialectic seems preferable for it preserves the essential ambiguity of the modern tradition. "What is paradoxical about modernity," he wrote, "is that it has a history, whereas it has always been captive to the eternal fellow creature of mass production." No theory will guarantee historical necessity to either modernity or the avant-garde. Though the periodization that results from the exclusive privileging of the new as a criterion of modern art is unsatisfactory—because after the emergence of modernism in the nineteenth century, it rules out any distinction in modern art and merely implies a quickened pace of renewal—the criterion and the periodization that Bürger substitutes for them are no more persuasive: once again, they are teleological and tautological. Bürger basically ignores the profound despair of Adorno, for whom all newness is destined to be swept away tomorrow, a position that brings him close to Baudelaire and Valéry and may be bourgeois. In his *Aesthetic Theory,* Adorno cites Valéry as his authority in identifying the compulsion to reject as the foundation of the new, which thus loses any political basis it might have. Thus Valéry wrote: "In the nineteenth century, the rebellion-revolution idea quickly ceased to convey the idea of violent reform (in view of the sorry state of things) and became the expression of an overturn of what currently exists as such, *whatever it is.* The enemy becomes the recent past. What matters becomes the change in itself, etc."

For Adorno as for Valéry, the authority of the new, the acceleration of renewal may be historically inevitable in bourgeois society, but by the same token no instance of the new is historically necessary. Bürger struggles against a conception that makes newness historically necessary, indistinguishable from arbitrary fashion; he challenges a dialectic that makes the artistically new both an adaptation to capitalistic consumer society *and* a resis-

tance to that society. But must we choose between Adorno's historical pessimism, mingling all of modern art in the one category of the new and its acceleration, and Bürger's historical optimism, opposing a necessary avant-garde to an ambiguous modernism?

In fact the historic meaning given the new—when it is seen as destined to be superseded—had appeared before the historical avant-gardes—in the 1880s as we have seen—and it already seemed indicative of a resistance to modernity in which the ephemeral and the eternal are inseparable. Bürger shares the historical hope of the avant-gardes who deny the uncertainty peculiar to new art, postulate a history, and flaunt a theory in the name of which the disappearance of the present would mean a takeover or redemption. No one more clearly warned against this illusion than did Walter Benjamin: he emphasized, in the words of Jürgen Habermas that "teleological constructions of history" based on the concept of progress have also served to "close off the future as a *source* of disruption." It is precisely because Adorno's view is close to Baudelairean modernity and because Bürger's view, which insists on a theoretical criterion of historical newness, is consistent with the avant-gardes that we may be allowed to dismiss them both in order to present the ambivalences and aporias of both modernity and the avant-garde, for theoretical terrorism has no other virtue than to exorcise their paradoxes.

While emphasizing the duality of the new, Adorno, consistent with his ideas, also had some distrust of theories for offering only illusory guarantees of necessity. Thus he doubted the possible relevance, for both artists and critics, of dwelling on the relation between surrealism and the theory of the unconscious. He drew this skeptical conclusion: "Though art is never held to understand itself—and it is tempting to take the view that this comprehension of itself is incompatible with its successfulness—then we have no need to acquiesce in this programmatic conception reproduced by the commentators."

After all, interpretation necessarily expresses in familiar terms what is disconcerting in art. Adorno observed that interpretation "thereby sidesteps the only thing that would need to be explained."

The moderns did not have a theory. It was the avant-gardes who attempted to assure themselves of a future through theories. Theories and manifestos, however, are of no help in distinguishing kitsch from what later proves historically necessary, as is shown by the contradictory examples of abstraction and surrealism. In hindsight we can recognize the historical necessity of abstraction, which justified itself by obsolete theories; while the avant-gardist manifestos, far from reducing the autonomy of art, led to new types of conformism. Insurance cannot be taken out on history.

2

Abstract art first appeared in the years preceding World War I, more or less simultaneously with Kandinsky in Munich, Mondrian in Paris, and Malevich in Moscow. This coincidence across the world—or at least across Europe—is striking, all the more so because the three artists seem to have arrived at abstraction by very different and very deviant routes. Abandoning figural representation was such a radical and serious choice that it had to be accompanied by strange aesthetic and metaphysical speculations in its defense. The distinction between form and content expressed by the aesthetic principles of the eighteenth century, and then the growing autonomy of form in the nineteenth century were probably among the conditions that made abstraction possible. Abstraction having been finally attained, form frees itself from content to the point of becoming its own content, or better still it abolishes the distinction between form and content. The shift to abstraction may be explained after the fact in such terms, which are those of the orthodox narratives of modernism, but it was not such formal considerations that cleared the path for the painters to arrive at abstraction. Though

the very practice of painting since cubism was leading to abstract art, the first abstract painters all felt the need to justify their painting by a theory that made it acceptable to the public and to themselves as well. These three founders of abstract art all published explanations of what they were doing, but the relation between their theory and their practice is disconcerting. As we shall see, all three a posteriori invoked outdated doctrines to justify their prophetic intuitions. Should we therefore conclude, with Adorno, that doctrine necessarily represents a retreat from genuine aesthetic newness and is destined to miss its mark?

The first abstract work, it is said, was a watercolor painted by Kandinsky in 1910. The fact that it was a watercolor is probably not fortuitous. Baudelaire saw the quick genres or improvisation—drawings or sketches—as characteristic of modernity, and it took Kandinsky several years of patient work to achieve the same freedom in oils. He also had to write two books, *Concerning the Spiritual in Art,* published in January 1912, and *A Look at the Past,* an autobiographical sketch he wrote soon afterward, in which he mostly describes sensations from the time of his Russian childhood up to his renunciation of a legal career and his arrival in Munich in 1896 at the age of thirty. According to Kandinsky, the start of his quest for abstraction was the result of a curious experience: returning home one day at nightfall, he observed on a wall:

> a picture of extraordinary beauty, shining with a ray from within. I stood bewildered, then moved closer to this rebus-painting, in which I could see only shapes and colors, while its tenor remained incomprehensible to me. I soon found the key to the rebus: it was one of my own pictures, which had been hung upside down. . . . Then I knew definitely that 'objects' were harmful to my painting.

Kandinsky recalls the anguish that suddenly seized him as a void opened up before him. "What should replace the object?" There

was the fundamental question, accompanied by a fear of lapsing into purely decorative painting. Hence the extreme slowness and carefulness with which Kandinsky proceeded in his renouncing of the object and his search for pure forms, in contrast to the alacrity displayed by Braque and Picasso at about the same time, when they were discovering cubism.

Concerning the Spiritual in Art justifies the manner in which Kandinsky replaced the object. And this is where his linking up with the old nineteenth-century spiritualist philosophy really comes as a surprise. After an era notable for its materialism, Kandinsky foresees a new period marked by the rebirth of the soul:

> Art is entering on the path at the end of which it will once more find what it has lost—what will become once more the spiritual ferment of its renascence. The object of its search is not the material, concrete object, on which it concentrated exclusively during the preceding period—a stage now passed—but will be the very content of art, its essence, its soul.

According to Kandinsky, the genre par excellence in capitalism's heyday was realism, but this genre is henceforth obsolete. The twentieth century will mark the end of materialism, and Kandinsky, seeing the advent of a "spiritual turning point," sees himself as the prophet of an age in which art will be freed from nature and matter. In becoming immaterial, that is to say, abstract, it will be free to express the spiritual truths underlying a world of superficial appearances.

The movement of art is represented as a near-mystical elevation: "The spiritual life to which art belongs, and of which it is one of the mightiest agents, is a complex but definite movement above and beyond . . . into simplicity." The emblem of the spiritual life is thus a triangle that moves forward and slowly rises. The sections of the triangle are less and less inhabited as one rises within it, and at the apex is a lone man who "drags the heavy weight of a resisting humanity forward and upward."

Kandinsky continues to see the artist as a prophet or magus. Abstract art thus started out as a religious and metaphysical art, and it was only after the fact that it would be able to become part of the great formalistic narrative of the modernist adventure. Initially, in the mind of the first abstract painter, abstraction was supposed to make individual psychology extinct, to explore a world of meanings and energies, and to produce images with which we would all be able to commune spiritually.

Ironically, it is because of this time lag that the spiritualistic doctrine, which had already been discarded by the twentieth century, allowed Kandinsky, if not to find, at least to justify what he was intuitively substituting for figurative art. Kandinsky is one of those ambiguous artists who are torn between the centuries. He presents Maurice Maeterlinck as the visionary who achieved in literature the spiritual turning point the artist dreamed of achieving in painting. In music, he claims to descend from Schönberg as well as Wagner and Debussy. He feels close to the French symbolists and the English pre-Raphaelites, particularly Rossetti and Burne-Jones, whom he lumps together with Cézanne, Matisse, and Picasso, when in fact his own work is unquestionably in another league and its historical necessity is obvious.

But alongside the received ideas of the end of the nineteenth century, Kandinsky stresses emotion and inner need or instinct as the basis for the work of art. This, then, was what was justified through the spiritualist doctrine. He saw colors and shapes in themselves as the purest means for expressing emotion and responding to inner need. Independently of nature and symbol, colors and shapes are part of a network of spiritual correspondences in which Kandinsky believes: "Color," he writes, "contains a force that is still imperfectly known but is real, is evident, and acts on the whole of the human body." With this he produces, from a viewpoint of instinct, a very fine analysis of colors and their affinities with shapes, the sharp colors harmonizing with pointed forms (such as a yellow triangle), the deep colors

with round forms (such as a blue circle): "Conflict of sounds, balance lost, 'principles' overturned, the unexpected drum roll, great questions, aspirations with no visible aim, impulses apparently incoherent, chains broken, bonds snapped, joined again in one, contrasts and contradictions—that is what our *Harmony* is. The composition which is founded on this harmony is an agreement of colored and drawn forms which have, as such, an independent existence proceeding from Inner Necessity and constituting, in the resulting community, a whole which is called a picture." Thus, to Kandinsky's mind, an abstract painting is very far from having no meaning and it is the doctrine of spiritualism that makes it possible to maintain that it does have a meaning.

Such was Kandinsky's theory in the years from 1910 to 1914, after a stage in which he was influenced by neo-impressionism and fauvism in his use of color. The year 1910 marked the transition from the material to the spiritual. The curved patches of bright color can still be recognized as steeples, roofs, or tree trunks, even if they do not stand out from the rest of the composition. But in the unity of the canvases the particular elements are dissolved. In his fear of mere decorativeness Kandinsky was gradually giving up reality. External reality yields to emotion, especially in his watercolors. But the challenge was to find ways to restore the force and spontaneity of the first attempts in oils—how does one reconcile the speed of emotion and the slowness of execution, the inner time and the outer time? This is the basic problem of abstraction, which Kandinsky methodically worked on between 1910 and 1914.

His pictures at that time are divided into three types. First, the six *Impressions,* produced in 1911, "direct impressions of external reality." Next, "expressions of events of an inward nature," called *Improvisations* and numbered from one to thirty-five. Finally, the most complex, expressions "elaborated slowly, taken up afresh, examined, and worked on for a long time after the first sketches." In these large *Compositions,* instinct and

emotion are consciously worked on over and over, ending up in an absolute separation of art and nature. The first *Compositions* still evoke elements of the external world, but these gradually disappear in favor of an abstraction reflected in the *Compositions* of 1913. After this Kandinsky's work could be pursued with far less tension.

In 1914 Kandinsky returned to Russia, where he remained until 1921. With ties to the Bauhaus (where he taught until 1933, when he was forced to leave Germany for France), he turned toward ever more geometrical forms. But let us particularly recall the period from 1910 to 1913: the recourse to the spiritualistic doctrine to explain the shift to abstraction. *Concerning the Spiritual in Art* is not a manifesto of abstract art but an attempt at justifying after the fact a shift that was barely comprehended by the artist himself: "That which belongs to the spirit of the future can only be realized in feeling, and the talent of the artist is the only road to feeling. Theory is the lamp which sheds light on the crystallized ideas of the past." In the realm of literature Proust provides us with a similar disparity between the redemptive problematic influenced by Schopenhauer—the theory expounded in *Time Recovered*—and a novel that develops in a relatively autonomous way, but nonetheless requires this theoretical justification.

The case of Mondrian is even more striking. When he reached abstraction in 1914, it was as a missionary. A puritan by origin and a theosophist by conviction, he never ceased to dream of an indissociable aesthetic and ethical purity in his painting. The doctrine he appealed to was not spiritualism but a moral code in the name of which the aim of his paintings was the convergence of the good and the beautiful. Mondrian had been profoundly affected by his Calvinist childhood, his hesitancy about his vocation (he had thought of becoming a preacher), his discovery of theosophy around 1900, and finally, in Paris in 1912, of cubism. He found nature and its disorder intolerable—particularly

the greenness of the meadows in his native Holland—to such an extent that one can speak here of a repression of nature and extreme artistic sublimation. Theosophy, which aims at union with God through rules of life, appears as an esotericism in search of the secret laws of the universe. It presumes an elevation to the supreme truth through study and asceticism. It requires the giving over of the self to an ideal. It was through this pseudoreligious gobbledygook, ascribing to art a role of initiation into mystery and of sublimation relative to life and nature, that after the fact Mondrian justified his leap into the abstract, starting with the frozen still lifes he had been painting for many years. According to theosophy, to which Kandinsky also made reference, man redeems himself through action, rising above the physical and emotional world to reach the mental world. The theosophy that allowed Mondrian to renew his link with spirituality was the prerequisite of his painting. This neo-Platonist wrote: "Although an end in itself, like religion, art is the means by which we can grasp the universal and contemplate it in a plastic form."

But it was the Parisian cubism of 1912 that made it practical for him to abandon the landscapes and still lifes he had been painting since the start of his career. The switch was abrupt, unhesitating, and launched him on an aesthetic and ethical progression toward absolute abstraction, which he achieved in 1920. At first Mondrian painted the same motif over and over again, seeking thus to distill its abstract essence, to separate form from concrete content in order to identify it with an abstract content. The painter proceeded in cycles: the tree, the sea, the church delivered up their essences. From 1912 to 1914, the object was thus abandoned. But even here, the end of representation in no way implies the abandonment of meaning.

The belief in reincarnation and in the artist's mission in the advent of a harmonious society was thus required for Mondrian to move from cubism to abstraction. He now painted principles rather than shapes, and explained it all with a whole moral

phraseology. Art is a religion, and abstraction, a "new image of the world," makes it possible to rise to the essential. From 1912 to 1914 he went from cubism to the sign and then, until 1920, to what he called "neoplasticism." Of the sign he kept only the horizontal and the vertical, expressing symmetry and asymmetry, which are supposed to be the two laws of nature. Later he would feel he had reached the essence and truth of painting. To his mind it was not the journey that counted but only the outcome, in which colors themselves and all liberties of composition were abolished, leaving only right angles. Mondrian then attempted chromatic experiments, but soon reduced his palette to three pure colors—blue, yellow, and red—and painted more or less the same picture over and over for the next twenty years.

This journey is profoundly ambiguous. Mondrian thought of his entire artistic development as an esoteric, mystical quest; he always believed he was following theosophy and applying its irrational doctrine to painting. In retrospect the purification of shapes and colors that he arrived at now seems to us in perfect harmony with the rationalism and functionalism that prevailed in the early twentieth century. With Mondrian, the gap between modern or even futuristic practice and an archaic philosophy is far more striking than in Proust or Kandinsky. But Mondrian had probably not had his final say when he died in New York in 1944. The last canvases he painted there, such as his *Broadway Boogie Woogie* of 1942 with its bright, syncopated lines, might be seen to indicate a criticism of the demented rationalism that had governed all his work. These American canvases also suggest that Mondrian had developed a completely new sensitivity to popular culture. Meanwhile, theosophical discourse had enabled him to maintain that his painting still meant something.

The third "inventor" of abstract art, Kazimir Malevich, seems very quickly to have reached the limits of painting and the rejection of all meaning, between his *Black Square* of 1915 and his

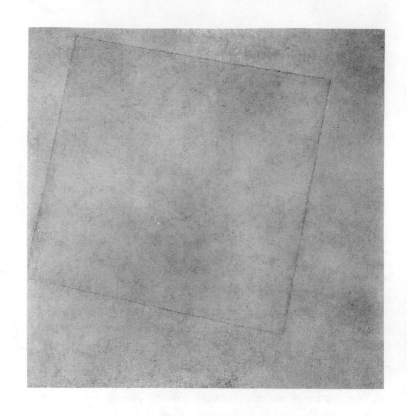

Kasimir Malevich. *Suprematist Composition: White on White* (1918).
Oil on canvas, 31$\frac{1}{4}$ x 31$\frac{1}{4}$".

White Square on White exhibited in 1918. But his is a quite singular combination of abstraction and Russian nihilism. Malevich's career moved quickly, from the impressionist pictures of 1903 to the final portraits of 1933–34. His avant-gardist work dates from 1915 to 1920: he launched suprematism in 1916; in 1917 he joined the political avant-garde, but he soon fell into official disgrace and returned to realism for the rest of his life. The speed with which Malevich moved from one stage to another is astonishing, as though he had immediately seen the endpoint of abstract art. Nevertheless, once he had reached the white on white, Malevich, like Kandinsky and Mondrian, attempted to justify himself.

Malevich's book *Suprematism or the Nonobjective World* clearly shows the influence of cubism and, with its provocative angle, of futurism, which became an international movement after the manifesto published in the Paris newspaper *Le Figaro* in 1908. But it was Russian nineteenth-century nihilism that most profoundly inspired his painting of the absence of an object. Suprematism and nihilism share many common features, both abjuring the objects of faith without giving up faith itself. In the realm of art, the stripping away of detail is based on the conviction that truth resides in the void; despair results from the wish for a world that will never be new enough; and the dream of redemption through art still remains. "In the vast space of cosmic stillness," wrote Malevich, "I have attained the white world of the absence of objects, which is the manifestation of emptiness revealed." In recounting his journey Malevich often resorted to a mystical vocabulary. Painting had been taken away from the world: it is silence, beyond the real. But for Malevich is this the end of painting or the beginning of a new world? Let us content ourselves with emphasizing once again the meeting of a historically decisive body of painting and an outmoded philosophy that serves as its pretext. Might we not find the same mixture, the same discrepancy, or the same tension in most of the truly innovative contemporary artists such as

Proust, Joyce, Eliot, Pound, and Kafka? New art does not proceed without archaism. It was thus with *Don Quixote,* in reaction to the conformism of the chivalric romance, that Cervantes gave birth to the modern novel.

3

In surrealism, a militant avant-garde that was aware of its historical role, the discrepancy appears to be symmetrical. Whereas the philosophy of the founders of abstraction lagged behind their painting, conversely, the often radical and extremist theoretical declarations of the surrealists gave rise to works that were often backward-looking and created a new form of academicism. Not that abstraction did not also produce conformism, but the urgent and polemical intellectual terrorism of André Breton left but faint traces on the path of art history.

In his first *Manifesto* of 1924, Breton attacked realism and positivism in painting and literature. After the break with Dadaism and Tristan Tzara in 1922, however, and after the failure of the Congress for the Establishment of and Guidelines for the Spirit of Modernism, he was no longer satisfied with anarchism, negation, and destruction but wanted to found a new aesthetic. From then on surrealism presented itself as a *dirigisme* or centralized authority: he thought he was in possession of aesthetic truth and intended to promote it by political means. In his *Manifesto* he defined it as follows:

> SURREALISM, n. Psychic automatism in its pure state, by which one proposes to express—verbally, by means of the written word, or in any other manner—the actual functioning of thought. Dictated by thought, in the absence of any control exercised by reason, exempt from any aesthetic or moral concern.
>
> Encyclopedia. *Philosophy.* Surrealism is based on the belief in the superior reality of certain forms of previously neglected associations, in the omnipotence of dream, in the disinterested play of thought.

Imagination throws out the old bourgeois logic but is no less imperious or constraining. From this definition it is inferred that automatic writing and the narration of dreams are privileged forms of the surrealistic text. To justify its practices, surrealist terrorism professes to be scientific. But what is the scientific claim of surrealism compared with that of, say, psychoanalysis, which is also concerned with the unconscious? The comparison of these two fields reveals the systematic dogmatism of the surrealist aesthetic.

Adorno, who, as we have seen, refused to accept the reduction of surrealism to an illustration of Freud or Jung, judged surrealistic works of art to be extremely rationalistic compared to the world of dreams, whose teeming riches were reduced to a few inadequate categories. In his eyes, surrealist theory was limited to the single practical concept of montage as the discontinuous juxtaposition of preexisting illustrations and images that had been created to give pleasure and diverted from their original context. Thus the only value in the reference to psychoanalysis was as an instance of special pleading.

Freud's interest in dreams and free association was of quite a different order from Breton's and their mutual incomprehension was considerable, stemming from the fact that dream elements in themselves do not interest psychoanalysis but only in a context made up of both the circumstances of life and the patient's associations to them. Surrealism, on the other hand, cuts out and isolates these elements from the process of their production and interpretation, presenting them to be read or seen such as they are. The unconscious material becomes its own purpose; it is fetishized in the form of simulacra. Breton presents these as the elements of a higher, transcendent reality that he calls surreality. The isolating of the elements of the unconscious life relative to the unconscious processes plays a deliberately obscurantist role relative to what could be expected of a science of the unconscious.

Nevertheless, the refutation of surrealism's scientific purpose

is not necessarily a condemnation of its aesthetic purpose. With the invention of abstract art, we have just seen examples of the discrepancy and contradiction between a dogmatic plan and aesthetic achievement. In this case, however, surrealism involves a different kind of contradiction. Spiritualism, theosophy, and nihilism were outdated doctrines that served to justify new and intuitive practices a posteriori; surrealism is an a priori ideology, a program that conceals aesthetic problems more than it allows for their formulation. Can we not see in the early history of surrealism many signs of a repudiation of modernity? In the 1930s, Louis Aragon, conforming to the destiny of many surrealists, reverted to the novel, the genre that had been irrevocably condemned in 1920 as the very embodiment of realism and positivism. However, as early as 1928, in his *Traité du Style* Aragon was endeavoring to define surrealism as both literature and antiliterature. I think that, underneath the coarse language, few texts better illustrate the dilemma of avant-gardes torn between negation and affirmation. According to him, surrealism is not a "perfecting of duly licensed freedom" or "a step forward toward free verse." Aragon rejects this evolutionary genealogy that recounts the adventure of art as a growing liberation and would like to see surrealism as a further stage of something else. Surrealism must be seen as something completely different, yet at the same time its forebears are constantly being unearthed. As soon as he sets about creating new values to replace those he destroys, he falls inevitably into the commonplace, or the conformism of nonconformism. In his *Traité du Style,* the moment surrealism tends toward affirmation Aragon makes every effort to defend it from the accusation of being a commonplace, in the name of a virtually unrevised idea of style.

Nevertheless the surrealists who did not disown the early avant-gardism and who persistently refused to be part of an artistic establishment soon ended up in silence and impotence, like Marcel Duchamp. Less absolute or heroic than Duchamp were the many painters whose names are still associated with

surrealism and whose works instead represent a continuation of fin-de-siècle aestheticism and symbolism: Chirico, Dali, Magritte, and Delvaux among others. Their painting is literary: that is the extent of its experimentalism. It persists in favoring representation, if only that of fantasies, instead of exploring the possibilities of the medium. This is confirmed by the importance of the title, and the interplay between text and the image, which soon became a major component of so-called surrealist painting.

Chirico was one the great precursors from whom surrealism claimed to descend. In Paris, between 1911 and 1915, he was a friend of Apollinaire's and Picasso's, and for some years after his return to Italy he painted a series of so-called metaphysical canvases, which he later disavowed when he returned to academicism and the copying of the masters. Even though, strictly speaking, Chirico did not belong to the surrealist group, having already repudiated his "metaphysical" work at the very time the surrealists claimed it as their own, his career is a shining example of the contradictions of surrealism. Here, contemporaneous with cubism, is painting with no technical refinement, but always mimetic, if only in that it represents another world, the world of dreams, as in Henri Rousseau. But the dream elements are represented such as they are, without the dreamwork or its interpretation: architecture, ruins, deserted squares and arcades, and blind statues constitute the scenery populated by mannequins, helmeted fencers, rubber gloves, and clocks. It is our world, the perspective is there, but because of the juxtapositions and the lack of proportion it comes across as having lost all reality. In *Les Pas perdus* Breton saw in Chirico's work a "genuine modern mythology in the making," and Aragon emphasized the presence of the collage with which he identified surrealism. But Chirico's montages, the strange, silent apparitions of his metaphysical period, provoke anxiety rather than the "wonderful" sought by surrealists.

After 1919 Chirico returned to reality, to culture, and to his craft. When the surrealists made him their beacon, they were also forced to condemn his apostasy. In 1928, against the painter's wishes, the Galérie Surréaliste held an exhibition of his metaphysical works and—this is significant—changed the titles of the paintings. In explosive language, Breton, Aragon, Duchamp, and Raymond Queneau attacked Chirico, possibly because he predicted the fate of surrealism as a new academicism.

Literary painting or literature in painting: at this intersection we can place Francis Picabia, whose career, though contemporaneous with Duchamp and Apollinaire, preceded surrealism and then continued beyond it with a gradual return to representation. From 1920 to 1923, however, he was at the very center of the surrealist adventure, with works in which words played an important role alongside drawings of mechanisms. Breton wrote of them in *Les Pas perdus*: "We recall that it was Picabia who once had the idea of entitling some circles *ecclesiastical* and a straight line *star ballerina*," and he praised what he called "one of the finest idealistic discoveries I know of." "No title," Breton continues, "creates an image or is used redundantly either. It is impossible to see it as anything other than the necessary complement of the rest of the picture." We see here that for Breton invention in painting is a matter of the *trouvaille,* the discovery of something brand new. In the same text Breton tells the anecdote of a Persian who accompanied Picabia to an exhibition and supposedly remarked: "Really, all these artists are mere beginners; they are still at the stage of copying apples, melons, and pots of jam," and, on hearing that the painting was very well done: "What is beautiful is to paint an invention well: this gentleman, Cézanne, as you call him, has the mind of a green grocer." Breton never fails to vilify Cézanne, probably the greatest of inventors, and this anecdote—which is surely not gratuitous and places Picabia on the scene—shows his incomprehension of painting as painting. In the same text, Breton praises

Picabia, "who was the first to paint the earth blue and the sky red," without bringing the earth or sky into question. For Breton, consists simply in the transgression of the real world.

It would be unjust to hold Picabia responsible for Breton's inaccurate remarks. He cannot be reduced to this though it is true that, like Chirico's metaphysical period, his mechanical period masks the problems of painting; but there is more to his work than that. On the other hand, when we think of Salvador Dali, a fellow traveler of surrealism from the late 1920s to the mid-1930s, it does appear that he did his best work during these years and that his taste for provocation—and dollars—later led him to mass production. A painting by Dali is eminently recognizable by its elements of mannerism combined with a number of surrealist inventions: on the one hand, the play with perspective, the distortion of figures, the precise contours and, on the other, statues and arcades à la Chirico, collage effects à la Max Ernst, and horizon lines à la Yves Tanguy. The imagination, which determines the details, dictates the layout, the flattening, and the flow of forms, but Dali adds great minuteness in the execution of detail. His technique of "critical paranoia"—"a spontaneous method of irrational knowledge based on the interpretive-critical association of delirious phenomena"—is connected with the surrealist cult of automatism.

Dali was the most gifted of the surrealist group; he was able to reconcile automatism and interpretation. But his painting soon became filled with self-referential clichés, and he left the group in 1935, for reasons that were both political (his chumminess with the extreme right, his wavering antifascism, his admiration for Hitler) and aesthetic (his taste for Ernst Meissonier and academicism, his archaizing perfectionism, and his return to overpolished and overfinished touches). Later in his career, during his "mystical" and "nuclear" periods, which made him enormously successful in the United States, he returned to conventionality.

But the two artists who seem to best represent the aesthetic contradictions in surrealism—with its cult of the strange leading to academicism in its depiction of the imaginary—are the Belgian painters Henri Magritte and Paul Delvaux, who took up surrealism in the late 1920s and the 1930s, respectively. From the start Magritte's works were conceptual: drawings with captions, playing with the idea of representation. In his most famous picture, *The Betrayal of Images,* (1928–1929), a pipe is depicted above the inscription: "*Ceci n'est pas une pipe.*" The distinction between the real object and the represented object thus brought into a painting was very stimulating to philosophers such as Michel Foucault, but this kind of painting is after all only an illustration of philosophical and linguistic problems, and with its clean and polished aspects it prefigures the comic strip and pop art. The fascination exerted by Magritte's work is linked to the reproduction of everyday objects, disoriented by language. But where is the automatism? No painting is more aware of itself. If the surrealistic image—defined by Breton, following Reverdy, as "The more the relationship between two juxtaposed realities is distant and true, the stronger the image will be"— results from juxtaposition, the clash of realities that have little connection with one another, such as a sewing machine and an umbrella on an operating table, this kind of surprise is exemplified in Magritte's 1934 *The Rape* (1934), which portrays a woman's face, with breasts instead of eyes, a navel instead of a nose, and a vulva instead of a mouth. Another well-known canvas, *Perpetual Motion,* also painted in 1934, in which the head of a man lifting a barbell is also one of the spheres of that barbell, eloquently poses the problem of the relationship between the world and representation. Or again, in *The Human Condition,* from the same year, a picture is set on an easel in front of an open window giving onto a landscape. But the depicted painting is exactly the same as the real landscape. All this is unsettling to the viewer. The artist repeated this trick endlessly. Magritte is an intellectualist, there is no spontaneity

in his work, and yet there still remains a naïveté about him, as though he were only just discovering what he was representing. But in the same way that surrealist poetry quickly ran its course, ending in a few clichés, the dreamlike painting of Chirico, Dali, and Magritte soon found its own commonplaces, providing the consumer society with a few vignettes.

Delvaux, who always painted the same woman with delicate brushwork, offers the best illustration of the destiny of surrealism in painting, which appears very much to have been to rejoin symbolism. Between the Swiss symbolist Arnold Böcklin and Delvaux, it is impossible to detect the extreme break postulated by Bürger between modernism and the avant-gardes. One finds women transformed into trees, deserted architecture, and the like. It is true that Breton never ceased to admire Gustave Moreau, whom he cited in his *Manifesto* as one of the precursors of surrealism, and it is tempting today to emphasize the affinities between decadentism and surrealism, rather than speak of a so-called surrealist revolution.

The view I have just set forth could be discredited on the grounds of its partiality: if, for altogether personal reasons, I do not like the mimetic painting of the fantastic, as Breton did not like Cézanne, that is no reason for disparaging it—or at any rate, it is a dishonest reason. Still, it is in terms of the innovative project constantly reaffirmed by Breton, that surrealist painting can be measured in relation to the avant-gardist doctrine of surrealism. On the other hand, I can hardly be said to have passed judgment on all the painters who were called surrealists; I have only mentioned those whose art went the way of the cliché despite or perhaps because of their avant-gardist discourse. It is in the others, however, that we can detect the questioning of the real in painting rather than the reiteration of its simulacra, and, after the fact, a determining influence on the history of painting: Arp, Ernst, Giacometti, Miró, Tanguy, and so on. Let us take the example of André Masson. It was he

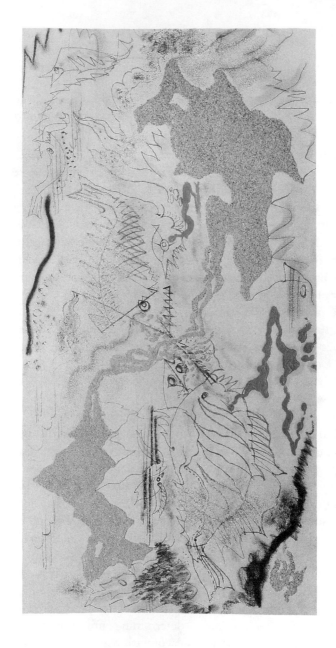

André Masson. *Battle of Fishes* (1926). Sand, gesso, oil, pencil, and charcoal on canvas, 14 ¼ x 28 ¾". COLLECTION, THE MUSEUM OF MODERN ART, NEW YORK. PURCHASE.

who, around 1925, offered the best expression of automatic drawing. Every work of his from this period seems to have been drawn with a single wandering, tangled, and stylistically ornamental line suggesting images lost in the interlacing. Masson's canvases were, nevertheless, cubist up to the invention, in 1927, of the sand pictures in which the role of chance foreshadowed American postwar action painting. Masson broke with surrealism in 1929, and his painting of spasm, tearing apart, and aggression is as different as can be from the fantastic academicism that was later to lead to pop art. As for Marcel Duchamp, whom we have not yet mentioned but who was one of the most eminent artists linked to surrealism, his art is inseparable from the two divergent trends in surrealist painting described here, which prefigure abstract expressionism and pop art, respectively. "The viewers are the ones who create the pictures," he would say.

FOUR

■
■
■ # A FOOL'S BARGAIN: ABSTRACT
■ # EXPRESSIONISM AND POP ART
■

Picasso said: "One can write and paint anything
whatever, since there will always be people to
understand it (to find a meaning in it)."
—Jean Cocteau, *Journal: 1942–1945*

The idol of the new flourished from Baudelaire to
surrealism, but at the present it is less than healthy and may
possibly be dead. It is time for us to consider its twilight. Our
own era, which people are pleased to label "postmodern"—
whether as posteriority or repudiation of the modern, one
hardly knows—seems to have confirmed the loss of the halo of
the new. However, this decline was prepared by a terrific out-
pouring of renewal after World War II. Adorno saw this speed-
ing-up as the inevitable effect of the aesthetic of the new, which
resulted from its ambiguous relation to the market; this is this
phenomenon I am concerned with here: the growing domina-
tion of the market over art and literature as well as their souped-
up mediatization.

As before, my remarks can be reduced to the analysis of a
paradox: whereas the modern tradition since the mid-nine-
teenth century, particularly the historical avant-gardes in the
early twentieth, reacted against the exclusion of art from mod-
ern life and against the religion of art—labeled as bourgeois
because of its sanctification of genius and veneration of original-
ity in the production of a unique, autonomous, and eternal
object—this tradition, far from linking up with mass culture
and popular art, has increasingly isolated itself in the world of

connoisseurship, meaning the elitist milieu confined to museums and universities, art criticism and galleries. Thus, the modern tradition did not abolish the distinction between "highbrow" and "lowbrow" art, elite art and mass art, great art and bottom-of-the-barrel art, or formalism and kitsch; it has even, paradoxically, sharpened this opposition, up to the emergence in the 1960s of forms such as pop art, which staged the death of art, that is, took advantage of the domination of the market to establish a complete identification between works of art and consumer goods. This did indeed abolish the distinction between elite art and mass art, but at what cost!

I shall recount the displacement of the art market after 1945 from the old world to the new—from Paris to New York—as a decisive element in the evolution of modern art, starting with the abstract expressionist movement that established American domination once and for all. I shall then suggest the importance of pop art in the 1960s for the definition or "de-definition" of art, to use the expression of the American critic Harold Rosenberg. It is at this point that I finally evoke a figure hitherto kept waiting in the wings, Marcel Duchamp, the pivot and prophet of this entire history of the end of art. Finally, I shall attempt to analyze the evolution in France from the New Novel to the New Criticism and so forth, in the context of the mediatization of art and the devaluation of the new.

I

After 1945 art moved from Paris to New York, a shift prompted by both history and aesthetics. During the war Paris had lost its market, its artists, its art dealers, even its collectors, and was unable to snap back after the Liberation. As early as 1942 a few major galleries, such as Peggy Guggenheim's, had opened in New York, exhibiting French artists and other European refugees, notably the surrealists: not only Breton, Ernst, Léger, Masson, Matta, Tanguy, Dali, and so on, but also Chagall,

Mondrian, Gropius, Mies van der Rohe, Brecht, Schönberg, Panofsky, and still others were involved in that brilliant academy whose reunion in New York had been triggered by Nazism. In 1945, even though most French intellectuals and artists—with the exception of Duchamp—returned to France, the war had speeded up the tempo of generational musical chairs, the political and economic context had radically changed, and displays by the old avant-gardes, such as the surrealist exhibition of 1947, seemed antiquated. The Parisian art dealers failed to regain their dominant position. They came up against a well-organized combine that included the American galleries, the powerful Museum of Modern Art in New York, and even the United States federal government, which, in the guise of the United States Information Agency, helped to promote American painting in Europe during the era of the Marshall Plan. The result was a series of pivotal exhibitions: "Twelve Contemporary Painters and Sculptors" in 1953, "Fifty Years of Art in the United States" in 1955, and "Jackson Pollock and the New American Painting" in 1959. Performing its office as protector of the free world, America discovered the merits of art, if not as propaganda then at least as a recruit in the service of a cause. The object was to establish that Europe's art was as passé as Europe's historical role in the new world politics. Art would henceforth be centered in New York.

What kind of painting was chosen to play the avant-garde role in the free world during the Cold War? In the 1930s, during the Depression, America had witnessed an important political and artistic movement aiming for a realism rather similar to that of the USSR and the frescoes of the Mexican artist Diego Rivera: the vaguely Marxist Works Progress Administration (WPA). To get an idea of this American realism, which was deliberately far removed from contemporary European painting, one thinks of Edward Hopper, recently reinstated after a long period in limbo. After 1945, however, something quite different

was adopted to represent America and compete with Marxist and Soviet ideology: a type of painting that bore the conspicuous stamp of French surrealism and also that of Marxism and Trotskyism: abstract expressionism. Jackson Pollock, Barnett Newman, Robert Motherwell, Mark Rothko, and Willem De Kooning were the heirs of the European avant-gardes who had fled Nazism and fascism. This choice was all the more strange, or shrewd, because this type of painting seems to express an opposition to Americanism or the pragmatism of "the American way of life" or, at any rate, an ambiguous expression of it because of its debt to automatic writing: in 1943 Pollock first exhibited his painting along with some surrealists at Peggy Guggenheim's Art of this Century Gallery. But according to Jean Clair, for example, the inoffensive puritanism of gestural abstraction made it ideal for becoming the official art of large multinational corporations. This kind of explanation unfortunately smacks a little too much of twenty/twenty hindsight.

American painting of the 1940s can be understood as a synthesis of impressionism and cubism, dominated by psychic automatism, which was regarded as a mere technique distinct from the surrealist theory that fetishized the products of the unconscious. According to another point of view from which the movement got its name, the experience of automatism as a technique of self-expression allowed for the displacing of Mondrian's geometrical abstraction to move toward an expressionism inspired by German painting. This expressionism—and this is the heart of the paradox—far from producing a more accessible art because it was based on experience rather than on theory, far from breaking down the barrier between highbrow culture and mass culture, in the spirit of the WPA and consistent with the American dream, resulted, for the first time in America, in a painting for the elite. Clement Greenberg, earlier cited in connection with his formalist interpretation of the modern tradition, appointed himself Pollock's spokesman, and abstract expressionism—from its first public showing to the

present day—became inseparable from its authorized version as set out by the critic, who saw it as the culmination of the European aesthetic evolution first launched by Manet. Without adopting Greenberg's historical viewpoint, and in order to emphasize the paradox of abstract expressionism, which oscillates between spontaneism and elitism, let us simply note that this type of painting remains inseparable from the intellectual discourse that justified it historically.

With Pollock's huge canvases, spattered with undulating lines, we may have reached a new limit in painting, as rigorous as Mondrian's and possibly the ultimate limit. Exemplary in this respect, the canvases from 1947 to 1951 are Pollock's essential contribution to painting. Defined in 1952 by Harold Rosenberg as gestural or "action painting," they are characterized by the action of dripping, in which the flow or squirting of liquid color is directed onto a canvas stretched out on the floor. As Greenberg noted at the start of his retrospective analysis, the canvases thus abolish all pictorial space, reducing the "shallow depth" that still remained in the cubist paintings of Picasso and Léger. The gesture and material are so rigorously connected that the canvas appears to bear traces of the gesture itself, like a snapshot. Earlier on I mentioned Masson's quite similar technique, beginning with his sand pictures but, through a reductive operation comparable to Mondrian's, this became the one and only procedure. Greenberg sees here the conclusion of "the crisis of the easel picture," to borrow the title of one of his best articles, published in 1948. Peculiar to Western culture, the easel painting generates the illusion of a three-dimensional cavity on the two-dimensional wall. In Mondrian himself, the perpendicular intersections and contrasts of pure colors still turn the surface into a window or a theater rather than a homogeneous and uniform flatness. Actually, the most noteworthy flattening of painting before then could be seen in Monet's last works, the water lilies he repeated over and over until his death. In their endless

continuum, they represent the first great example of "all-over" painting, meaning painting that covers the entire canvas with the same pictorial matter. According to Greenberg's definition, it is "a surface knit together of identical or closely similar elements which repeat themselves without marked variation from one edge of the picture to the other. It is a kind of picture that dispenses, apparently, with beginning, middle, end." Yet one aspect of the culmination of the modern tradition is the shift, or reversal, of the conventional question on the beginning of a composition—the problem is now where it ends: how does one know when the composition is finished? Balzac's prophetic novella, *The Unknown Masterpiece,* has thus become an allegory of modern art: the artist works for years on a secret picture and reworks it to such an extent that when it is finally unveiled, nothing more than a foot can be recognized in a jumble of lines.

The other pitfall of the all-over picture, ever in danger of falling between Scylla and Charybdis, is decorativeness in the manner of endlessly repeated motifs in wallpaper. This was what Kandinsky most feared before he ventured into abstraction. Postwar all-over painting, that of Jean Dubuffet's in France along with that of abstract expressionism in the United States, overcomes decorativeness by other means: monotony, blend of colors, and size. Greenberg describes Pollock's painting as "polyphonic," in an allusion to serial music since Schönberg in which the twelve tones are equivalent instead of being in a hierarchical scale. In the all-over painting "every element and every area of the picture [is] equivalent in accent and emphasis." This equivalency runs the risk of being read in terms of uniformity or monotony and of inducing boredom, which is the case in dodecaphony. But, even though it may seem anti-aesthetic, uniformity is itself a rather general given of modernism—from "high modernism" or elite culture in contrast to mass culture—as much in literature as in music and painting, for example in Virginia Woolf, James Joyce, or William Faulkner in English and perhaps the New Novel in French. Greenberg writes: "The

dissolution of the pictorial into sheer texture, into apparently sheer sensation, into an accumulation of repetitions, seems to speak for and answer something profound in contemporary sensibility." All-over painting disregards any scale of values, any cultural convention, so to speak—though we shall see that this is not altogether true; it is thus related to what Dubuffet called *l'art brut,* but with an American-style naturalistic ideology in which what has value and counts most is the authentic, the immediate, the spontaneous, the inspired, and the impulsive.

Starting in 1936 Pollock underwent several Jungian psychoanalytic treatments for his alcoholism, using his drawings for therapy. In 1942 he attempted automatic poetry, particularly with Robert Motherwell. The hastily sketched arabesques first appear in his wartime automatic drawings or on the background of canvases that are still figurative and extremely violent in their color and fragmentation, as in Picasso and Miró. But around 1946 Pollock did away with the relationship between figure and background in his first all-over canvases, which repeat the same dissolving gesture and appear as inextricable networks of commas occupying the entire canvas, with paint applied thickly at first, then more liquid colors. By the end of 1946 the canvas shows through the tangles of enamel painting, as if to indicate lack of completion, and here again, as in Kandinsky, raises the problem of time, duration, and speed. The painter is searching for a manner that relates to the totality of the canvas, its entire extent, at every moment, every instant, rather slowly composing it by filling it in with one brushstroke after another. Thus, in 1947 Pollock replaced his easel with the floor of the shed where he had his studio, and his brushes and pigments with a stick and liquid colors, particularly enamel paint.

Pollock circles around the canvas stretched out on the floor and attacks from every side, as though performing a dance. The painter is *in* the painting, with no intermediary, as he himself said, and he constantly increased the size of his canvases to

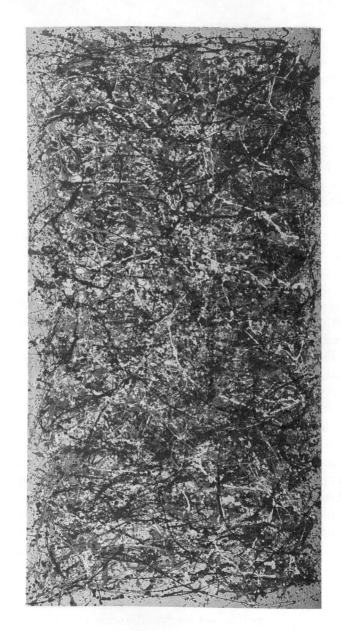

Jackson Pollock. *One (Number 31, 1950)* (1950). Oil and enamel on unprimed canvas, 8′ 10 x 17′ 5 ⅝″.
Sidney and Harriet Janis Collection. The Museum of Modern Art, New York.

magnify this experience. Their great size necessarily eliminates the illusion of depth, as well as the constraint of a frame. The invention of abstract expressionism was linked to the huge size of the canvases, which Motherwell said in all seriousness were a logical result of the spacious New York lofts occupied by painters during and after the war.

For five years Pollock hastily painted a great variety of these labyrinths, black interlaces on the white canvas, or complex tangles of various colors. The entire surface is covered with crisscrosses. The contrasts are no longer worked out in width but in thickness. The spurts of color disappear into each other. Spots form a network connected with threadlike lines or, as in his *One* of 1950, where a white grid appears on the surface, looking like mold. Sometimes it is a shower of droplets. But what can be the meaning of these meanderings? Is there any meaning beyond pure automatism?

The viewing of a collection of Pollock's canvases—the most beautiful and complete can be found in the Peggy Guggenheim collection in Venice—gives one a feeling of controlled systematicity, of a secret plan that seems hard to reconcile with the technique of automatism and the theory of unconscious creation. What this type of painting achieves is clear, comparable in its aim to that of Mondrian, eliminating the distinction between figure and background; "the canvas having to appear," writes Hubert Damisch, "as the physical medium for successive lines every one of which would ultimately embrace the totality of the space given to the gesture." But how do we make the leap from surrealist inspiration, which the painter often claimed for himself? Though surrealism enabled Pollock to free himself from American and Mexican realism, it was also necessary—in order for him to apply automatism to the large surface on which he absolutely insisted—that he reject or disregard the very concept that, as we have seen, linked surrealism to European symbolism and led many artists back to an academic style. In fact, the key concept of surrealism is montage, and the surrealist

value par excellence is the image resulting from the arbitrary juxtaposition of two distant realities. Pollock's greatest period corresponds precisely to the rejection of the image and a highly precise substitution of the process for the object. Thus the painting makes us see creation itself in its immediacy. The painter does not rework the creation, it is identified with the very gesture that has only just been broken off. In this sense also, Pollock embodies a boundary of European modernity, refusing to conceal the conventions of painting behind the painted object.

In fact, through a new trick of history, the extremism of abstract expressionism can be traced to its American origin. Because it is American, this type of painting brings to a culmination all the paradoxes of modernity even more sharply than does the European tradition. Abstract expressionism is American because of its pragmatism, even its naïveté—that of the child or convalescent, as Baudelaire said—expressing the work itself in a single-tracked, crude or primitive way, rather than concealing it in the finished object. Far from withdrawing from the canvas, the painter remains within it. Pollock always spoke of his intimate and intense relationship with the canvas, describing his physical insertion into his painting as the condition for his success. "When I am *in* my painting, I'm not aware of what I'm doing. It is only after a sort of 'get acquainted' period that I see what I have been about. I have no fears about making changes, destroying the image, etc., because the painting has a life of its own. I try to let it come through. It is only when I lose contact with the painting that the result is a mess. Otherwise there is pure harmony, an easy give and take, and the painting comes out well." In an excellent film made by the photographer Hans Namuth that shows Pollock at work, we see how everything unfolds according to perception, without the intervention of the image. Once the first sketch has covered the canvas—either arbitrarily or according to its shape—the successive lines react at an accelerated rhythm, in a perfect conver-

gence of emotion, gesture, and line. This film itself is one of the Pollock's most beautiful works, as if the painter were merely a go-between bringing the painting to life.

Pollock's final years were marked by a lack of clear direction. Elements of representation reappeared in his work, born of the interlacings themselves; the lines were no longer deployed solely in terms of the surface to be covered but made use of recognizable images on the surface, in the network of black and white. And the specific format no longer systematically governed the beginning of the sketch. In the canvases of 1952 we can thus recognize faces as well as human and animal silhouettes. Randomness is no longer absolute. The image breaks up the uniform space of the canvases from 1947 to 1951, evoking or at least allowing for a more traditional reading consistent now with the surrealist aesthetic; in this sense the image represents a sign of failure, for until then Pollock's painting addressed itself only to perception, not to the imagination. It was perceived optically, but also as a rhythm, the rhythm of the dance that had produced it, a whole body in motion. By the time of Pollock's premature death in 1956, his painting had come to a conclusion some years before.

In comparison to the work of some other members of the New York school, Pollock's painting between 1947 and 1951 seems the most authentic and immediate that has ever been produced, in direct contact with basic drives: a coming together of emotion, gesture, and line. The entire drama lay in the conquest of this ephemeral convergence, the present seen afresh as pure presentness. This kind of painting is also highly disconcerting because of the uniform distribution of lines on the canvas and the lack of a focal point of interest. Paradoxically, it was given meaning from the point of view of extreme critical formalism, recounting the entire history of modern painting since Manet as that of the progressive reduction of its fictive depth, a gradual purification toward its vital essence, identified with a medium freed of all extraneous conventions. With the New

York school American spontaneism—Pollock himself traced his art to Native American sand drawings—paradoxically gave the great art of the 1950s its accepted and exported form, the final stage of a formal history and an idealistic narrative of art conceived as autonomous in relation to life. As frequently happens, this painting was taken seriously in opposition to its proclaimed intentions, not for its emotional or sublime themes, not for the spontaneous feelings that it wished to communicate, but from a strictly cultural point of view, as the ultimate form of elitist art, sanctioned by the market and fetching very steep prices by the 1960s.

2

Today pop art seems more dated and outmoded than abstract impressionism, but the latter's reversal (spontaneous art promoted to elitist art) by the former (conceptual art promoted to mass art) seems to be an essential step toward the discrediting of the new in a consumer society. The great names in pop art are famous precisely because their works were mass-reproduced as gimmicks: Robert Rauschenberg, famous for his use of scrap materials; Roy Lichtenstein, famous for transposing comic-book images into large-scale compositions; Jasper Johns, identified with his series of American flags; and Andy Warhol, the great one-man band. Pop art turned upside down all the choices of abstract expressionism with regard to tradition, art criticism, and the market. Two of Rauschenberg's earliest works can be cited as typical of pop's attitude toward art. First is his *Bed,* a large composition of the artist's sheets, eiderdown, and pillow, wildly smeared with thick paint. A true meeting point between the technique of abstract expressionism and sensitivity to incidental objects, Rauschenberg's *Bed* was produced in 1955, at a time when, lacking the money to buy a canvas, he seized his eiderdown, spread it out on the floor, added his pillow, and attacked the whole thing with paint. This *Bed,* recently offered

by the art dealer Leo Castelli to the Museum of Modern Art, has been valued at somewhere between seven and ten million dollars.

An earlier work done by Rauschenberg in 1953 was even more literal in its destruction of art and consisted in erasing a drawing by De Kooning; it was exhibited under the title *Erased De Kooning Drawing* after being signed "Robert Rauschenberg." Rauschenberg had asked De Kooning for a drawing he could erase, and De Kooning had consented. It took Rauschenberg a month of work and forty erasers. By presenting the public with a soiled and damaged sheet of paper, to which the establishment gave the status of art, Rauschenberg provoked the viewer and forced him to give up the traditional experience of aesthetic perception, which had been hitherto respected by the modern tradition. He thus forced the viewer to accept the negation of art, that is, its reduction to an institution and a market: art is whatever the artist calls it and whatever the galleries exhibit. After abstract expressionism, which was the profound, ultimate exaltation of autonomous art—pop art, developing another aspect of surrealism earlier illustrated by Dada and Marcel Duchamp, and making the cynical use of the market, abolished the distinction between elite art and mass art: pop art benefited from the end of art.

The political paradox, mirroring that of abstract expressionism, is that this art, which depended on the consumer society, was seen in the France of 1968, for example, as a protest against that society rather than as a paroxysmic manifestation of its laws. Oddly, pop art was seen as a first expression of the democratization of art, on the grounds that it elevated a can of soup and a Coca-Cola bottle, endlessly reproduced, to the rank of art object. Pop art seemed a liberation from the religion and the tedium of art that abstract expressionism had prolonged; it extended beyond the confined atmosphere of galleries, critics, and art dealers; it used vivid colors; and it connected art and

life, which had always been the goal of modern art, though never attained, as, generation after generation, it rediscovered its role of ritual and religion for the elite. The protests against the art establishment, which via the market have always co-opted modern art, disputatious and subversive as it might be, were nothing new. What *was* new, however, was pop art's anticipation and exploitation of its *own* co-optation through the mechanisms of the market. Thus, to understand the nature of pop, it is instructive to compare it with the earliest radical attempt to dedivinize art: that of Marcel Duchamp between the wars.

Independent of any value judgment, Duchamp's work represents one of the most thorough reflections on art in the twentieth century, in a world dominated by technology. Ever fascinating, ever topical, and wreathed in a myth that never seems to die, it has its champions and its enemies. More than anyone else, Duchamp helped rid the creative act of its mystery and divest the artist of his aura of genius that had been inherited from romanticism and on which most of the surrealists depended. He made of the artist a craftsman, but not in the style of William Morris and John Ruskin, who had praised manual work in their struggle against the stepped-up industrialization of late nineteenth-century society and culture. According to Duchamp, the modern artist, no longer working for a protector or patron, has become a kind of small entrepreneur. He produces objects without practical value or use, and in the market to which he delivers them demand does not precede supply. It is therefore up to the artist to decide for himself what he will make, and the collector then gives his verdict by choosing whether or not to buy. Disengaged from public reproduction, the artist, who must *produce* demand, or some exchange value that has no use value whatever, paradoxically becomes the embodiment par excellence of capitalism, including its contradictions. Thus, the state of modern art is a result of the artist's

no longer depending on a patron who commissions his work but instead putting his objects on an anonymous market. The artist therefore decides what to produce, but the market decides whether or not it is art. Taking note of the preeminent role of the art market, Duchamp, who called himself an "anti-artist," abolished the opposition between art and nonart. Identifying the artist with the craftsman and the craftsman with the producer, he introduced the machine and its powers of reproduction into the realm of art. Duchamp's work is a fine anticipatory illustration of Walter Benjamin's thesis in a well-known essay, "The Work of Art in the Age of Mechanical Reproduction."

After a brilliant start with cubism, and a few major works done in 1912 and 1913 in which he attempted to set cubism in motion, as for example with *Nu descendant un escalier* and *Le Passage de la vierge à la mariée,* Duchamp ceased to apply himself to the uniqueness of the work of art and gradually gave up painting, which, requiring not only the use of the hand but also some skill, experience, technique, obscures the obvious domination of the market over the object. Duchamp soon performed an experiment in provocation. After being forced to withdraw his *Nu descendant un escalier* from the Salon des Indépendents in Paris in 1912, he exhibited it in 1913 at the New York Armory Show. The painting, which served to initiate Americans into the methods of the avant-garde, caused an uproar because it presented a series of flat lamellae arranged in parallel to create identical shapes reduced in size, temporal succession, and the static representation of a body in motion. Probably the title, which today seems quite inoffensive, was also shocking; as it turned out, it prefigured Duchamp's tendency toward an ever more conceptual and nominalistic art.

The technique of parallelism of element and lamellar intersection was soon exhausted. Besides, the modern acceleration of speed made this physical and static representation of movement seem inadequate and unsatisfactory. A title such as *Roi et reine*

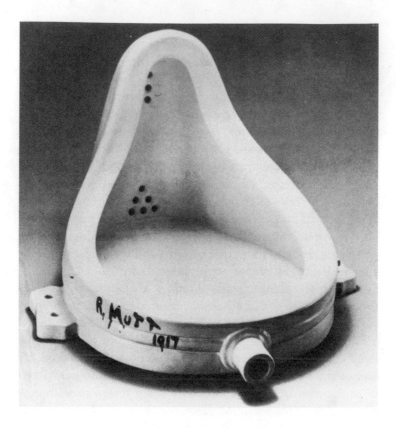

Marcel Duchamp. *Fontaine,* 2d version.
THE SYDNEY JANIS GALLERY, NEW YORK.

entourés de nus vite (1912) indicates that the expression of movement was really more poetic than plastic. Then pseudovisceral mechanical style took over, particularly in the *Le Passage de la vierge à la mariée* (1912), which is more or less static and devoid of realistic reference. With *Le Grand Verre, ou La Mariée mise à nu par ses célibataires, même,* a "masterpiece" painted between 1915 and 1923 and left unfinished, and later with the *rotoreliefs* and primarily the "ready-mades" (manufactured objects that were either modified or left untouched, then signed, given titles, and exhibited, thus being promoted to the rank of *objets d'art* only by an arbitrary decision of the artist), art became increasingly challenged by technology; here was the logical culmination of the collage of the cubists and soon afterward of the surrealists, which had been made aesthetically equivalent, though within the framework of a picture, to manufactured fragments, natural materials, and painted forms.

The ready-mades created by Duchamp beginning in 1912—incidental objects or assemblages of them, such as the bicycle wheel set on a footstool of 1913—challenged all the traditional notions of the work of art: creativity, originality, beauty, autonomy. The ready-made was clearly iconoclastic and all the more so at the time. Decontextualizing the object and giving it a title, he carried to its highest point pictorial nominalism, that is, the substitution of the linguistic for the plastic in art, or of the discourse on art for the art object, ever silent in its revolt and therefore subject to appropriation. On the other hand, Duchamp insisted on the indifference that ruled his choice of object. He wrote in his *Boîte blanche:* "The object's claim on the creator who chooses is not based on the attraction exercised on him as a function of his taste, but on indifference, neutrality, that is, on a total aesthetic absenteeism, an absolute 'anesthesia.'" The bicycle wheel had long been lying around Duchamp's studio, but its assemblage on the footstool was circumstantial. The ready-mades had to remain resolutely "nonartistic," and to avoid their giving rise to any kind of aesthetic, their number

had to be limited. The same goes for the wine racks of 1914 or the snow shovel of 1915 (*En avance du bras cassé*) or the hatrack of 1917; but a ready-made such as the *Fontaine* exhibited in New York in 1917—which is simply, or aggressively, a urinal with its vertical side placed horizontally and signed *R. Mutt* and hence dissociated from its normal function—remains one of the best examples of Duchamp's non- or anti-art. Here the total integration of art and nonart is complete, there is no way that pop art could go any further. The concept was simply redupli-cated and exploited commercially, whereas Duchamp had scrupulously observed the principle of rarity. The ready-made rules out beauty as an aesthetic criterion, and at the same time Duchamp maintained that art is nothing more than "ready-made," that is, an assemblage of manufactured products the artists fiddles around with, such as tubes of paint and a canvas.

Harold Rosenberg called the ready-made "an anxious object," because one cannot tell whether or not it is a genuine work of art. From then on, what could make something a work of art if not our attitude toward it? The ready-made was the first illustration of what Jean Clair called the "relations of uncer-tainty" that affect aesthetic ideas, similar to scientific thought since Heisenberg: "Can we observe a fact said to be 'artistic' out-side of the conditions of observation that a priori make it appear to us as such?" Once Duchamp's work was exhibited in art galleries and museums, the art market, despite all the "anti-artist's" precautions, took over his ready-mades. The critics quickly set about looking for and finding aesthetic qualities in them—seeing for example, a sculptural beauty in the movement of the bicycle wheel set on the footstool, and the white, polished surface of the urinal, which was compared to a sculpture by Brancusi or Henry Moore.

Is it not also true that the ready-made, situated at the oppo-site extreme of art, nonetheless left intact the value of past art? We could probably also detect in Duchamp's attitude a nostalgia for great art or at any rate an ambivalence toward machinism

and "the age of mechanical reproduction." It was not lightheartedly that Duchamp pushed to its limits a logic that, since the mid-nineteenth century, has deprived painting of its cultural functions—religious, historical, philosophical—and restricted it to the visual or formal experience of the medium, with the market as its only sanction. Duchamp pressed on to disaster. Once reproduction and repetition have entered the domain of technology, which is a better provider for the market than the artist, the only thing left for the latter to do is avoid repeating himself and tirelessly, gloomily continuing his search for the new. This is why Duchamp shied away from showing off his innovations. The gesture of negating art cannot be repeated, otherwise its critical function is nullified in the affirmation of other objects and other values that take the place of works of art and aesthetic values: this is what pop art was to do, taking advantage of Duchamp's lesson in terms of quantity, in other words going against Duchamp. Instead of the market and the patrons, Duchamp made himself the patron in a series of subversions. But even though the art world reappropriated Duchamp, his work, produced essentially between the two wars, remains an outstanding example of posing the problem of art's survival in modern society and continues to disconcert those who would like to maintain some continuity with the art of the past.

How can we judge the value of Duchamp's work, so often described as a practical joke or hoax, from the *Nu descendant un escalier* of 1912 to the posthumous work *Etant donnés: 1. la chute d'eau, 2. le gaz d'éclairage?* Is it still art? Duchamp's work wishes precisely to confront us with the arbitrariness and absurdity of any problematic of artistic value. To those who criticize Duchamp for causing a crisis in art and bringing about its demise, we might suggest that he seems in fact to have been aware of a crisis that already existed. Furthermore, we can hardly blame him as both a practical joker and the destroyer of art. This would amount to admitting that not much was needed to achieve this.

On certain precise points the aim of pop art can be compared to Duchamp's. In the early 1960s (1962 and 1963), Andy Warhol produced a series of portraits of Marilyn Monroe, then reproductions of the *Mona Lisa* with the transparent title of "Thirty are Better than One." These works, in the form of mass-produced posters, spread through every college and university town in the free world. Through a serigraphic or silk-screening process, Warhol could produce the same image six by five times, in rows, within a rectangle: not just any image but the most famous one of all, not the image itself but a photograph. The number of degrees separating the posters in teenagers' bedrooms from the painting in the Louvre is countless. Art becomes the reproduction of a reproduction, in this case that of a black-and-white photograph of a Hollywood star or of the most famous picture in the Louvre and possibly in the entire world. The work of art is the simple, unlimited repetition of an image taken from the media, and the artist relinquishes any individuality to slip into the anonymity of mass production. But does this represent a criticism of culture or simply an exploitation of the art market? The answer is easy to find if we recall that Warhol, in multiplying the *Mona Lisa,* was playing not only with *the* painting par excellence—and the perfect symbol of bourgeois taste since the leisure society began spreading the vogue for tourism and museum-going—but also taking a cue from Duchamp's ready-mades and outdistancing (and by the same token negating) Duchamp's own ambiguous position, both repudiative and nostalgic, with regard to great art.

In 1919 Duchamp had scribbled a mustache and a goatee on a photographic reproduction of the *Mona Lisa,* entitling this corrected ready-made *L.H.O.O.Q.,* an acronym whose pronunciation, which corresponds to "she has the hots," confirms the humorous and iconoclastic intent of the "correction." Duchamp knew how to shock the bourgeoisie but, ever ambiguous, he ridiculed not so much painting and art as the modern religion of art epitomized by a reproduction of the Louvre mas-

terpiece within the reach of every pocketbook. Duchamp was attacking not so much tradition as its popularization and decline into kitsch. But the ambivalence of art itself—or of the bourgeoisie that to a certain degree tolerates its being laughed at—means that art can be assimilated, can recover, and hence can defuse any attack against itself. This is probably one of the reasons why Duchamp withdrew after 1923, since his works, which were supposed to overthrow bourgeois art, merged with it and added to the public's alienation and to the lack of comprehension of art. For those who remember the *Mona Lisa*'s official visit to Washington in 1963, and the high mass of art celebrated by André Malraux for the Kennedys, a further fall from the pedestal of art was the agenda for the day. But Warhol's criticism turned into a celebration of himself. Certainly Duchamp and Warhol had something in common, if only the *Mona Lisa*. Duchamp, possibly the last to suffer from the passion for the new, wavered between a taste for great art and a furious criticism of culture, in terms of a tearing apart peculiar to the avant-garde, and he retreated into silence. Warhol, on the other hand, who like a number of other pop artists came out of the world of advertising, wavered between criticism and the market, cashing in from both sides. This ubiquity led him to the opposite extreme of silence, to wit, idle chatter, repetition, and the massive dissemination of imitations that were totally devoid of critical power. The difference remains that between the avant-garde still linked to the tradition to which it is opposed, and kitsch. But as often happens with extremes, avant-garde and kitsch sometimes become as one.

When the time came, Duchamp responded to Warhol. In 1965 New York's Museum of Modern Art, the high altar of modernism since 1945, held a Duchamp retrospective that ironically established him—Duchamp, the unique iconoclast—as one of the great masters of the twentieth century and the most farsighted beacon of the postwar period. The invitation card, designed by Duchamp, was a simple reproduction of the

Mona Lisa—respectful now of her facial features—on the back of a playing card with the caption, "L.H.O.O.Q., shaven off." After being ridiculed by Duchamp in 1919 and multiplied by Warhol in 1963, the *Mona Lisa* regained her glory, avenged, as it were. For the historically knowledgeable viewer, Duchamp, in reaction to the repetition of provocation—because repetition undercut the efficacy of provocation and turned it into a stereotype—was emphasizing, for the benefit of Warhol and the public who accepted the marketing of negativity, the greater purity of true criticism.

Thus the comparison between pop art and Duchamp's negative and critical purism shows to what degree the large-scale commercialization of criticism, that component inseparable from modernity since Baudelaire, proclaims the end of modernity. Starting with pop art we can speak of the modern tradition, because it is now drawing to a close. The desacralization of art ends, curiously, in the fetishization of the artist, for in his very person, his very body, he represents the only thing left as a criterion of art after the triumph of the ready-made. The artwork is contained in his signature, making the artist the locus of art. A picture is an image, any image that bears a signature. The signature becomes equivalent to a brand-name label for manufactured objects—Warhol or Colgate, it makes little difference what is behind the label. And the fame of a signature is won through the artist's self-advertisement, through the marketing of an image. Warhol's work, his Campbell's soup cans or his multiple portraits of media stars, indefinitely repeated, is in a sense emptier than Duchamp's near-silence after 1923; it takes Duchamp's message literally, interpreting it strictly in terms of the art market. Thanks to the silk-screen process, supply can always meet the demand it creates. Abstract expressionism had given rise to a final form of elitist art, but the 1960s society demanded a more quickly consumable art. Pollock and his generation of artists wanted to be painters of subjectivity. Warhol's

media image is completely superficial and devoid of any individuality. It is a mask with nothing behind it: "I am what I seem," he said, "there's nothing behind it." One may assume that there is nothing behind art for the market either. Hence the extraordinary symbiosis between Warhol and the art market. All the artist's creativity was aimed at cultivating his own image to the heights he reached in 1966, when he advertised that he would append his signature to anything presented to him, including dollar bills.

Here at last is the result of more than a century of modern tradition: art is now nothing more than an item of merchandise. The opposition between the artist and the public, between the elite culture and mass culture, is now dissolved. Whereas postwar American painting has remained deeply marked by the European tradition, all respect for great art has now become irrelevant, for contemporary art no longer has tradition as an opponent but only the media as a partner. All that remains of Baudelaire's dandy, the embodiment of the modern hero, are the old clothes of Warhol's black-leather uniform. But where has the melancholy gone? Art, now totally devoid of transcendence, is reduced to commercial speculation.

Ever ironic, history decreed that the modern tradition should end in pop art, in which the literal interpretation of every criterion of modernity leads to a radical skepticism regarding modernity and art. Far from representing the cultural revolution, as the generations of 1968, especially in Europe, believed, pop art disclosed the elitist and esoteric nature of the modern tradition as well as the dependence of all art on the market. After pop art, people went on talking about minimal art, conceptual art, hyperrealistic art, "body art," and the like, but all that seems trivial detail compared to the vogue for postmodernism.

3

Between the time the modern tradition moved across the Atlantic after World War II, until its denouement or retraction

in pop art, what was happening in France? In America the modern took hold in painting rather than in literature, while in France painting linked up with the prewar era or trailed in the wake of American painting of the 1950s: comparisons have been made between Dubuffet and De Kooning, Nicolas de Staël and Mark Rothko, among others. On the other hand, the French literary movement in French literature—with what was called the *nouveau roman* in the mid-1950s, after Alain Robbe-Grillet's *Les Gommes* and *Le Voyeur*—can be linked to the flattening of painting by abstract expressionism, or the leveling out of music by dodecaphonism, because of their common reduction of values. In order to avoid hasty parallelisms and banal generalizations, let us speak only of an analogy in the pursuit of equivalence and standardization. French literature simply made up for the time lost before the war with surrealism, with technical mastery of style in the manner of the *Nouvelle Revue Française,* then, during the Liberation with the *littérature engagée* finally catching up with the international modernism of Joyce and Woolf, Musil, Kafka, and Faulkner, who had not yet been much read in France. Influenced by phenomenology, Sartre brought its ideas into his *La Nausée,* but the book still had the conventional form of a naturalistic novel and ended in a scene caricaturing the redemption of life through art. Céline created a new style of writing in his *Voyage au bout de la nuit* where the spoken language invades the entire narration, but he could hardly represent modernity, for he was deported for collaborating with the Nazis. As for Raymond Queneau, who in his first novel, *Le Chiendent,* had produced a truly new form, he confined literature to word games. The only one remaining was Camus, whose *L'Etranger* was on the scale of the international modernist tradition. This is the list of writers mentioned by Roland Barthes in his *Writing Degree Zero* (1953), though they are more representative of the end of the prewar period.

From the start Robbe-Grillet challenged the notion of the avant-garde, which had been sustaining the modern tradition

for nearly a century. In 1963 he collected his critical remarks under the programmatic title *Pour un Nouveau Roman,* but despite this catchword the very idea of the new was mercilessly attacked in his book. According to Robbe-Grillet's way of thinking the new was probably still too closely associated with Dadaism and surrealism, and Robbe-Grillet has nothing of the iconoclast or anarchist about him, as his autobiography has since made clear. In a 1957 article entitled "Sur quelques notions périmées," he rejected the avant-garde label, which, "despite its air of impartiality, most often serves to dismiss—like a shrug of the shoulders—any work that risks giving mass-market literature a bad conscience." In a 1988 interview Robbe-Grillet justly observed that the initial bad press for the *nouveau roman* was the doing of critics "who knew very little about twentieth-century literature, Joyce, Kafka, or Faulkner for example. They had not even read—or had misread—Proust." Decked out in the adjective "new," the *nouveau roman* therefore made no claims to any break and most particularly rejected the accursed heroism of the avant-gardes.

Barthes, whose *Writing Degree Zero* had already defined the literary movement of the twentieth century as a purification, played a role for the *nouveau roman* and Robbe-Grillet that was close to that of Greenberg for Pollock and abstract expressionism. He lent them legitimacy by speaking of a literature of the object in contrast to a literature of the subject, but today the ambivalence of this literature is all the more striking, for its *chosisme* was also a "mentalism" as well. The term *abstract expressionism* concealed the same ambiguity. Robbe-Grillet now says that the *nouveau roman* later went as far as "textualism," which casts doubt on the psychology of the subject that had been left intact in the early manner of the *nouveau roman* as it was in the modernist novel before it: Joyce's *Ulysses* multiplies levels of consciousness without doing away with the problematic of consciousness. From *chosisme* or mentalism to textualism, the *nouveau roman* followed the path of the human sciences, which

have destroyed the solidity of the subject, following Lacan, Foucault, and Derrida. In its very ambivalence, in its uncertain play with subjectivity, the *nouveau roman* thus appears a rather good historical equivalent to American painting.

In the 1960s, on the other hand, a set of writers emerged who were sustained by a powerful revolutionary rhetoric, but ended up adjusting quite easily to the domination of literature by the media and the market. Philippe Sollers—starting with the *nouveau roman Le Parc,* proceeding from the Maoism of the journal *Tel Quel* to best-selling novels—represents analogically (though here again, I am merely suggesting the comparison) the same brazen playing with the marketplace as Warhol, in his identification of the book with the writer and of the writer with the public image. The journey of modern criticism symbolized by Proust's break with Sainte-Beuve is to be traveled all over again. The paradox, which again is the same as pop art's, stems from the momentary perception of this kind of literature as part of a counterculture subversive to bourgeois culture. Twenty years later, in fact, it does seem as though French Maoism constituted an excellent school of management for the men in power in the 1980s.

The adjective "new" retained some value in the France of the "Glorious Thirty," the years from 1944 to 1974, in which the New Wave, the New Criticism, the Nouvelle Cuisine, the New Philosophy, or even the New Towns, were so many heady PR slogans. This universal extension of the label "new" is definitely the sign of its devaluation and is inseparable from the mediatization of the culture and the market's domination over art. However, in order to avoid ending with the grim conclusion that the media brought off what the modern tradition could not or did not really wish to do—that is, draining art of any religion or sacredness—let us compensatorily stress the benefits of separating art from the culture that was born in reaction to this situation. Is it not true that the malady of modern art, its curse, resulted from its always having asked aesthetic questions in

cultural terms? This also explains the temptations of an exclusive formalism. But what is art outside of culture—or outside formalistic evolutionism? By way of an answer I shall cite two names: Jean Dubuffet in painting and Samuel Beckett in literature.

FIVE

■
■
■ ## OUT OF STEAM:
■ ## POSTMODERNISM AND RETRACTION
■

"All in all, to the idol of Progress corresponds
the idol of the curses of Progress, and that makes
two commonplaces."
—Paul Valéry, "Words about progress," 1929

Postmodernism, the new cliché of the 1980s, has
invaded the fine arts (if the expression is still appropriate), liter-
ature, the plastic arts, possibly music, but primarily architec-
ture, and also philosophy, etc., which were weary of the avant-
gardes and their aporias as well as disappointed by the tradition
of rupture that was increasingly assimilated by the consumerist
society's fetishism of marketable commodities. As we have seen,
art since the 1960s has become more and more indistinguish-
able from advertising and marketing. The postmodern unques-
tionably includes a reaction against the modern, which has
become a scapegoat, but the term's very form—like those of
postmodernism and *postmodernity*—immediately presents us
with a logical difficulty. If the modern is what is current and
present, what can the prefix *post-* possibly mean? Is it not con-
tradictory? What could be the "afterward" of modernity as indi-
cated by the prefix, if modernity is endless innovation, the very
movement of time? How can a time be said to be after time?
How can the present deny its character of being the present? For
now, we shall say that the postmodern is primarily a polemical
catchword, which lodges a challenge against the ideology of
modernity, or modernity as ideology, in other words not so
much the modernity of Baudelaire (in its ambiguity and its

wrenching duality) as the modernity of the historical avant-gardes of the twentieth century. It follows that if modernity is complex and paradoxical, so is postmodernity.

A recent American dictionary gives the following definition of postmodernism: "A movement or style characterized by the renunciation of twentieth-century modernism or by its rejection (including modern and abstract art, avant-garde literature, functional architecture, and so forth) and typically represented by works incorporating a variety of historical and classical styles and techniques." The epithet *postmodern* was first used by the historian Arnold Toynbee in the early 1950s, but in a quite different sense that made it nearly synonymous with *decadent, anarchic,* and *irrational,* designating the final phase of modern times and Western history, the European decline that set in during the last quarter of the nineteenth century and was confirmed by the two world wars. The adjective cropped up again in the 1960s, still used pejoratively, among American critics— such as Irving Howe in his collection of essays eloquently entitled *The Decline of the New*—who set themselves up as defenders of modernism against a new anti-intellectualism favored by a postindustrial society dominated by the media and marked by an end to ideology. In this sense postmodernism, which appears as a sociological phenomenon before it becomes an aesthetic, is the ideology, or nonideology, of the consumerist society.

And then, in the 1970s and still in the United States, the term was taken up again, this time in a sense both optimistic and polemical, especially in Ihab Hassan's book *The Dismemberment of Orpheus: Toward a Postmodern Literature* (1971). Orpheus, the very hero of modern literature, frequently cited by Maurice Blanchot, is torn apart a second time. Hassan relates the movement of literature to a social phenomenon, a major mutation in Western humanism that he unhesitatingly calls a change in *episteme* or "discursive formation" in the sense used by Michel Foucault. Having acquired this philosophical legitimacy, postmodernism became a more general term designating the entire

contemporary aesthetic and intellectual landscape, marked by unquestionable changes. It remains no less difficult to decide whether postmodernism corresponds to an authentic change of *episteme* or "paradigm" in Thomas Kuhn's sense, and whether it gave rise to original forms or merely recycled older processes in a different context. Is postmodernism a continuation of modernism or a breaking away from it? In either case, is it positive or negative?

In the late 1970s the term emigrated to Europe, notably in Jean-François Lyotard's *The Postmodern Condition: A Report on Knowledge*. Meanwhile in the United States it was argued that an affinity existed between artistic techniques called postmodern and French theories called poststructuralist (Lacan, Barthes, and Derrida). then in the 1980s the concept extended well beyond the reference to a new style; it turned into a veritable ragbag. Jürgen Habermas, a consistent advocate of modernism and severe critic of the postmodern, saw the catchword of postmodernity as the refutation of modern reason since the Enlightenment, and identified it with a political and social neoconservatism. But how does one relate this sense of postmodernism to the application of the word to architecture, where it denotes a reaction against functionalism?

There is a flagrant paradox in the postmodern that claims to have done with the modern but, in breaking away from it, reduplicates the modern process par excellence: the rupture. Gianni Vattimo gives us an excellent description of this paradox in *The End of Modernity: Nihilism and Hermeneutics in Postmodernism Culture:* "For if we say that we are at a later point than modernity, and if we treat this fact as in some way decisively important, then this presupposes an acceptance of what more specifically characterizes the point of view of modernity itself, namely the idea of history with its two corollary notions of progress and overcoming." Exemplifying a contradiction in terms, does the postmodern represent modernity's final manifestation? Or does it represent a real turning point, the valediction to the modern?

Is it not merely a novelty in relation to the modern, and as such still caught up in the logic of innovation? Or does it succeed in "dissolving the category of the new"? Does it put an end to the dogmas of development and progress? This is asking a great deal, and the postmodern provokes all the more skepticism in France because the French did not invent it, yet we pass ourselves off as the inventors of modernity and the avant-garde as we do of the rights of man. After briefly considering architecture, where there is some consensus on the meaning of *postmodern,* and discussing the use of this notion in literature and plastic arts, I shall then take up the sociological and philosophical question of the postmodern "paradigm."

I

In France, the term *postmodernisme* is largely restricted to architectural style; that is how the *Petit Larousse* defines it. Though in English "postmodernism" has a wider applicability, it came into vogue through its reference to architecture and seems to have a more exact meaning in that field than anywhere else. It denotes a contemporary trend—not just American, but also European and Japanese, though less common in France—that contrasts with so-called modern architecture. Postmodern architecture aims to break with the functional international style; it demands the right to eclecticism, localism, and reminiscence; it has its roots in a tolerant syncretism, as opposed to geometrical purism. Modern architecture, characterized by rationalism and the primacy of function since the beginning of the century, is accused of breaking with the life of forms. According to the modernist adage "Form follows function," the starting point for the rational approach is, in the opinion of its detractors, an ideal, inhuman, and uninhabitable cube rather than a very real cabin or hut.

The architectural movement that calls itself postmodern is thus based on the principle of modernism as a dead end; modernist architecture began with the Bauhaus, which was founded

in 1919 by Walter Gropius and disbanded in 1933, at which Kandinsky and Mies van der Rohe taught, and played a leading role in the International Congress of Architecture founded in 1928. Peter Blake's 1974 *Form Follows Fiasco*—whose title is an inspired pun on the functionalist slogan—constituted a milestone challenge to modernism. According to this new slogan, the functional approach usually produces failures, and the building best adapted to some given function is preferably one that has been diverted from its originally intended function: the best concert hall is a former garage, the best museum an old railway station or an abandoned slaughterhouse. Many diversions of function have indeed been achieved, and a long series of architectural errors cast doubt on the functionalist credo, disproven on every point—such as Adolph Loos's famous comment "Adornment is a crime," or "Useful = Beautiful"—that aimed to do away with tradition and sanctify the new. Opposing the dogmas of the tabula rasa and incessant renewal, as well as the quest for unity and identity, postmodern architecture privileges a practice that is ingratiating and unpretentious.

Another charge leveled at architectural modernism is that in its eighty years of existence it has been unable to form a history and adds up to a few great names clustering around the same oft-cited trinity: Le Corbusier, Mies van der Rohe, and Frank Lloyd Wright. The modernist utopia dates from the end of World War I and the Russian Revolution and imposed itself with the dream of a Europe reconstructed on new foundations integrating urbanism and architecture in a plan for social transformation. Architectural modernism originated with an enlightened ideal: rational design was to be consistent with a rational society based on the myth of modernization and the rejection of the past; machinism is seen as the source of happiness and blossoming as, for example, in Le Corbusier's house-machine. But the fiasco of modernism soon became evident when the Bauhaus was exiled to the United States: technology had given birth to totalitarianism. After 1945 modern architecture no

longer had a plan for society and it enlisted in the service of power. Once standardized, it lost the negative and critical quality that was indispensable to the modernist movement. It became modern in name only and was synonymous with the alienation and dehumanization exemplified by skyscrapers, parallelipiped structures, and huge apartment blocks. The assembly line met with a similar fate; hailed in the 1920s as liberating, in both the Soviet Union and the United States, it was a discredited object of revilement thirty years later.

The premise of social postmodernism—to which architecture is all the more sensitive because of its direct connection with technology and social reproduction—rests on the acknowledgement of modernization's failure to provide liberation and, on the contrary, whether in the United States, the Soviet Union, or Europe, on the discovery of man's growing alienation in present-day urban life and the leisure society. This was a serious blow to the idol of reason and the respect it had been accorded for more than two centuries. The exact date of the end of modernism, according to Peter Blake, is July 15, 1972 at 3:32 P.M. (more or less), when several St. Louis apartment buildings built in the 1950s were dynamited because they had become uninhabitable. Such a fate, narrowly escaped by some of Le Corbusier's "radiant cities," perfectly illustrates the deterioration of the myth of modernism with its metaphors of the machine and the factory.

Here we see—in a subtractive way, as it were—the postmodern movement as a calling into question of the widely accepted belief in the indefinite modernization of the city, in innovation as a value in itself. But this is not enough. If there such a thing as a distinctive postmodern aesthetic—and not merely a group of individuals lumped together under this label after the fact by publicists—it must be definable by some positive identifiable features. This is what Charles Jencks tried to do in his *The Language of Post-Modern Architecture* (1977), which has the air

of a manifesto. According to him, postmodern architecture is characterized not merely by its rejection of the modern movement but also—though this could be merely one of its side effects—by its similarities to other historical movements from which postmodern architects have sometimes explicitly claimed to be descended. Nostalgia for the forms of the past and claims of affinities with other architectural traditions, such as the baroque and mannerism, go hand in hand with the protest against the modernist dogma with its purism and absolutism.

Postmodernism, which does not set out to be revolutionary, is no longer based on a myth of the future—a myth of man, society, or of modern cities. On the contrary, since the postindustrial society has given up every ideal, one must be content with a modest, fragmentary architecture with mixed codes. Whereas modernist architectural rationalism, believing its calling to be universal, ran up the same building in Manhattan, Brazil, and Timbuktu, postmodern architecture has appropriated local traditions. Not wanting to throw out the modernist baby with the functionalist bathwater, defending the original ideal of modernism despite its later degradations, Jencks commits himself to a dual or ambiguous architecture that turns both to gradually evolving local traditions and to architectural technology with its accelerated mutations. He argues for an architecture with a split personality, as it were—in this he is fairly typical of contemporary culture—favoring nonsynchronicity instead of always placing himself at the cutting edge of modernization.

Palinode or retraction, postmodernism thus goes against the critical negation of the history of forms on which modernist messianism was founded. Running counter to the dogmas of coherence, balance, and purity that are foundational to modernism, postmodernism reevaluates the ambiguity, plurality, and coexistence of styles; it cultivates both vernacular and historical "quotations" or references. The reference is the most potent

figure of postmodernism. The postmodern architect dreams of contaminating the historical memory of forms with the myth of novelty. To borrow a term from literary criticism, let us say that postmodernism aims at a "dialogue" between heterogeneous elements. Its goal could be summed up by the expression "dialogical architecture," an interplay of forms from various traditions laid end to end in time and no longer seen in their historicity.

The precursor of this generalized contamination was the American architect Robert Venturi, who in his *Complexity and Contradiction in Architecture* (1966), advocated a type of architecture concerned with its users and based on collage, a living architecture—though not following the nineteenth-century organic model—that was adaptable and devoid of abstract ideals. His second book, *Learning from Las Vegas: The Forgotten Symbolism of Architectural Form* (1972), makes a clean break with modernism, judging its architecture to be inappropriately elitist. Venturi replaces it with an architecture without an architect—or with the most discreet architect possible—uncritically employing the languages of the consumerist society. Venturi goes so far as to give the example of the "Strip" in Las Vegas—with its casinos, motels, and neon—as the model of heterogeneous, complex, and contradictory architecture par excellence and the contemporary equivalent of a Gothic cathedral. With its anarchy of billboards and clash of images it is the model to be followed by the postmodern architect. In his *Collage City* Colin Rowe generalizes this analysis to include all cities, including Manhattan, and goes beyond the neutral and utopian grid of its "rational" urbanistic plan and so adapts itself to modern life. In contrast, the modern is identified with policing and totalitarian control. A sign of the times: Venturi has yet to design any important public buildings. His proposed design was accepted for the extension of the National Gallery in London, no doubt because it touched a populist nerve. Prince Charles, who has gained a reputation for reviling modern archi-

tecture that destroys the urban fabric, contributed to the cancellation of the earlier project: postmodernism goes hand in glove with traditionalism.

Postmodern constructions often have an air of pastiche or parody. According to the age-old dialectical movement between imitation and innovation, could we be witnessing a period of imitation in the realm of architecture? The prefix *post* would then mean nothing more than a retreat. After an age of gigantism, it suggests the opposite of a plan or an ideal set in the future: a blasé and skeptical glance at the past fully spread out before us, without history or hierarchy. In the absence of faith in the future, the past loses its historicity as well and is reduced to a repertory of forms. No longer trying to create history or change the world, since that has never produced anything but fiascoes, inhuman cities and buildings—this is Paolo Portoghesi's thesis in *Postmodern, the Architecture of the Post-industrial Society* (1982)—postmodernism reopens the age-old debate about architectural ornamentation along with that of figuration in painting and realism in literature.

In 1980 Portoghesi organized an exhibition entitled "The Presence of the Past" for the Biennale festival in Venice, also shown in Paris in 1981. Several architects had been invited, each constructing a sort of introductory "portal" to his work. The one by the American architect Michael Graves called to mind the Palazzo del Te in Mantua, designed by Giulio Romano in the early sixteenth century. A number of mannerist elements were duplicated in a play that diverted them—the upside-down keystone, for example—from their normal use. The house of the director of the saltworks at Arc-et-Senans, designed by Ledoux at the end of the eighteenth century was reappropriated in the "portal" of Ricardo Bofill, whose neoclassical constructions at Saint-Quentin-en-Yvelines, Montpellier, and Montparnasse are well known. Portoghesi himself openly

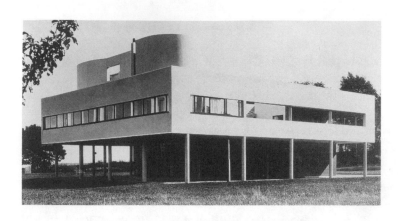

Le Corbusier and Jeanneret. Savoye House.
Poissy-sur-Seine, France. 1929–30.
PHOTOGRAPH COURTESY THE MUSEUM OF MODERN ART, NEW YORK.

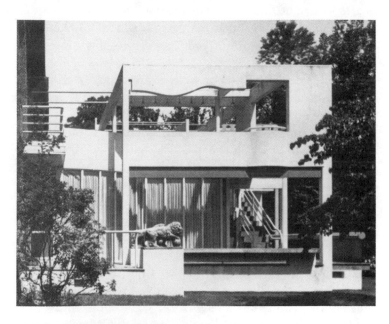

Michael Graves. Maison Benacerraf, 1969. Princeton, New Jersey.
PHOTOGRAPH COURTESY LAURIN MCCRACKEN.

played on the shapes of Borromini's Oratorio di San Filippo Neri in Rome, which dates back to the dawn of the baroque. Constituting a sort of postmodern manifesto, these examples show that the trend has achieved an international dimension.

From the postmodern viewpoint, modernism is now considered part of tradition and hence represents one historical form among others that can be potential sources of elements to be reworked. Thus, in 1969 Michael Graves, a postmodern before the term existed, miniaturized and parodied, not to say ridiculed, Le Corbusier's Villa Savoye—a masterpiece of architecture as a total and pure object—in the annex he designed for the Benacerraf house in Princeton. Whereas Le Corbusier's construction was a closed totality, a unique, enclosed object, the parodistic character of the Graves design comes through in the fact that it is merely an addition to an existing, somewhat nondescript house in an American suburb. Whereas the Villa Savoye is isolated by its piles and solarium, the same elements as "quoted" by Graves are devoid of any function. The stairway, so well-integrated in Le Corbusier's house, becomes the signature of incompleteness in the Benacerraf house, like a piece of architecture still under construction. The rejection of the modern utopia could scarcely be more unmistakable.

Because the emblem of modernism is the curtain wall, the smooth glass facades of Mies van der Rohe, it was through their own facades that the postmodernists announced their rupture loud and clear. The classic symbol of postmodernism soon became Philip Johnson's AT&T Building (now the Sony Building) on Madison Avenue. Its shape, now as easily recognizable as that of the Empire State or Chrysler buildings, has already been flatteringly echoed by a perfume bottle, that kitsch object par excellence. With its Roman columns at street level, its neoclassical middle section, and its Chippendale pediment—whose model was a Pittsburgh house in the nineteenth-century American tradition—this stone skyscraper (whose erection necessitated the reopening of an abandoned quarry near New

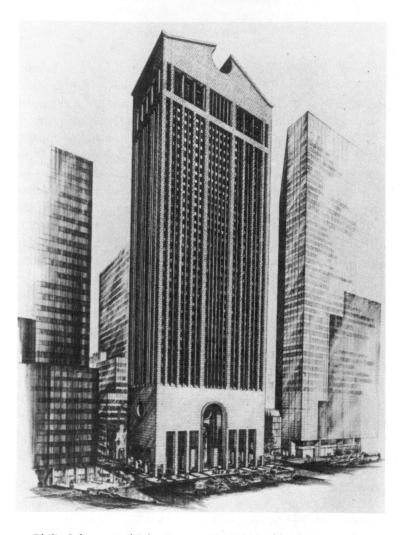

Philip Johnson and John Burgee. AT & T Building, New York.
PHOTOGRAPH COURTESY GIL AMAGIA.

York) has sometimes been compared to fascist architecture. The analogy should not bother anyone, however, since postmodern references claim detachment from their original contexts. An apolitical attitude goes hand in hand with the repudiation of history, and the apostates feel no remorse. A modernist up to the 1970s, even to 1976 with his Pennzoil Place in Houston, Johnson has become the preeminent postmodernist.

The French scene, in which the model of the factory still carried the day with the functional juggernaut of the Beaubourg museum, has been let off relatively lightly by the postmodern offensive, with the exception of Bofill or the "follies" in the park at La Villette designed by Bernard Tschumi, who borrowed from Russian constructivism. Among the major building sites of Paris, the Arche de la Défense is wholly modernist. Its construction was a technical tour de force, but, typically, its spaces turned out to be ill-adapted to its users. I. M. Pei's pyramid in the front courtyard of the Louvre plays a manneristic game with its context, but remains a pure object of technology. Paul Chemetov's Ministry of Finance and Jean Nouvel's Arab World Institute, though they bow to the recent trend with the addition of a few North-African-style *moucharabieh* ornaments such as external balconies enclosed by latticework, in no way contradict the functionalist credo. In France, the modernist model is thought to be still alive: pure, unlivable, beautiful, terrifying, ideal, and punishing. Architects content themselves with adding a pinch of references in new day care centers, schools, and police stations. The impeccable curve of the Centre National d'Industrie et Technologie at La Défense is patriotically glorified but its space is partitioned into offices that completely alter its original character. *Le Monde,* in its 1988 obituary for Emile Aillaud—the last superstar of the high-density housing blocks—did not hesitate to call him one of the first to bring back humanism—colors and curves—to the international style: "Quite incorrectly taken to symbolize the disaster of the great housing projects, he is in fact . . . the first thinker of the new

architecture in France." Is this not an instance of typically Gallic reasoning, declaring that postmodernism in France was quite pointless—on the pretext that no foreign influence was needed to correct the excesses of modernism?

2

Since its triumph in architecture, postmodernism has spread to art in general, to sociology, philosophy, and so forth. Breaking away from the tradition of rupture, how can it be defined other than as a syncretism or an area of extreme tolerance? "Anything goes," proclaims the historian of science Paul Feyerabend, author of *Against Method* (1975) and advocate of an anarchistic or nonrational epistemology. An ideology of the end of ideologies, postmodernism is characterized throughout by permissiveness and the renunciation of criticism.

In literature, for example, the American novelist John Barth, who considers himself a party to postmodernism along with Thomas Pynchon, Robert Coover, and John Hawkes, characterizes the movement as synthesis in contrast to antithesis, the idea being to have done with a long list of restrictive oppositions judged typical of modernism: realism and the fantastic, partisans of form and partisans of content, pure literature and *littérature engagée,* elitist fiction and mass-market novels. One of the postmodernists' most frequent complaints against the modernists is the asceticism their works demand of their public: austere and ambitious, they are said to be inaccessible and give no pleasure; these are the very qualities that make them elitist. Postmodern writing, on the other hand, looks after the well-being of its readers, just as postmodern buildings take care of the people who live in them. In this regard John Barth mentions Italo Calvino's *Cosmicomics* (1965) and Gabriel García Márquez's *One Hundred Years of Solitude* (1967). Characterized by fantasy and the baroque, these novels are like gulps of cool water after the parched aridity of modernism up to the *nouveau roman.* On foundations as vague and tenuous as these, anything

and everything seems to be validated, the best and the worst: "Anything goes." But the dichotomy on which Barth's analysis is based, between an anemic literature and a revitalized literature — *The Literature of Exhaustion and Literature of Replenishment* is the title of his 1982 book—seems somewhat Manichean.

The American postmodernists claim to derive, moreover, from illustrious precursors, notable among them Borges, Nabokov, and Beckett. But these three authors have little in common, save their play with the conventions of representation. And in France, and in Europe generally, these writers are usually classed with the modernists, together with Michel Butor, Claude Simon, Alain Robbe-Grillet, Milan Kundera, and so forth, all of whom are considered clearly postmodern in America. It is as though there were a time lag between America and Europe, and modernism came to an end at different dates on the two sides of the Atlantic. In America the general tendency is to consider postmodern just about everything written since 1945, after T. S. Eliot, while in France it seems that no one noticed the end of modernity or reacted against modernism until the energy crisis of the early 1970s. The "Glorious Thirty" still belong to modern times, notably with the vogue for the human sciences. But in America these are thought to be poststructuralist, and it has been said that between poststructuralism and postmodernism there is but one short step. There, it seems as though, after the beginning of the Cold War, the only imaginable future was some form of catastrophe—and is not the postmodern consciousness primarily the end of any faith in the future? Hence the usual reciprocal incomprehension in discussions between Americans and French, with the French admitting that Robbe-Grillet became postmodern when he wrote his life story but arguing that he was not so previously. In this area also, Europe seems to have lagged behind America by about twenty years. And although it is true that the emergence of postmodernism—in the pejorative sense of kitsch and then in the optimistic sense of celebrating the counterculture and throwing

out what was punitive in modernity—did indeed coincide with the triumph of the consumerist society, it is also true that this triumph occurred in France well after it did in America.

Taken seriously, however, postmodernity cannot be thought of as a simple matter of periodizing: after the Korean War or after General de Gaulle. What are the main figures and mechanisms of postmodern literature? Unfortunately, writers who have studied the problem mention features that were also present in modernism, such as the uncertainty and indeterminacy of meaning for the reader. This was precisely the same parameter as in Friedrich's orthodox narrative from Baudelaire to Mallarmé, so that poetry would appear to have always been more or less postmodern. Was it the novel that changed? It can no longer represent reality but simply possibilities that it declares void one by one as they are evoked. But was not the Proustian sentence, with its twists and turns of hypotheses and torrents of conditionals, already postmodern? And the ebb and flow of *Finnegan's Wake?* And the fall into the void of *Voyage au bout de la nuit*: "Let us not mention it again"? The line between literary modernism and postmodernism is always pushed back, another reason for the divergences between the two sides of the Atlantic.

If called upon to name a novel combining all the most frequently mentioned features of the postmodern—indeterminacy of meaning, the calling into question of narration, the showing of the reverse side of the scenery, the retraction by the author, the sudden questioning of the reader, and the integration of the reading—I would think first of all of the fine 1946 novel by Louis-René des Forêts, *Le Bavard,* on which both Maurice Blanchot and Claude Bonnefoy have written. A character in the novel describes several scenes of idle talk but then backs down and exposes his story as a lie and truly meaningless chatter; he takes the reader to task and, in the final word, nothing is left. But why should we qualify this story as postmodern?

All this leaves us in some perplexity. Is the postmodern more modern than the modern; a reaction—particularly in painting—to the institutionalization and assimilation of the modern, which, since 1945, has given up nihilism and become a self-regulating mechanism of bourgeois culture and society? Is the postmodern antimodern or premodern, that is to say, neoacademic and conservative? Is it the extreme of the modern, the ultramodern, the metamodern, or simply a return to the soap opera or adventure novel: a regression that justifies itself by denouncing the modern? These things might conceivably all be the case, the term *postmodern* involving several realities. Was there after all any greater unity in the modern? The prefix *post*, moreover, suggests the rejection or impossibility of a positive reference. And then, since rupture is eminently modern—people have said it—the breaking away from the modern would be the very height of the modern! We find here the paradoxes and ambivalences that have haunted the entire modern tradition, but even more intensified. How can we recognize the authentically new and differentiate it from the "neo" that immediately becomes "retro"? This is all the more difficult to do since the truly new has most often endeavored to be a renewal or rebirth. What are we to think of the renewal of representation in painting? Or the return of the author in literature? Robbe-Grillet, Nathalie Sarraute, and Marguerite Duras, now writing their autobiographies, say that nothing has changed. In the great confusion of the "anything goes" of today, could it not be precisely all those modern dichotomies that have been jumbled together and so cancel each other out?

Up to this point I have taken pains not to conflate modernism with the avant-garde. But from the viewpoint of postmodernism, do they not come down to the same thing? In the first edition of *Faces of Modernity* (1977), toward the end of the chapter entitled "The Idea of the Avant-garde," Matei Calinescu, rather condescendingly treated postmodernism as

roughly synonymous with the counterculture that advocated populism as a replacement for modernist elitism. In this sense postmodernism would be akin to the historical European avant-gardes of the 1920s, but this debases their intention since "popular" would then mean *saleable* and *successful commercially*. Even though postmodernism would eventually become an instance of the joining up of two extremes—avant-garde and kitsch—initially it retained some of the polemical and provocative aspects of the earlier avant-garde. On the other hand, in the second edition of his book, written in 1986 after the postmodern globalization, Calinescu makes a distinction between postmodernism and the coalition that now seems to be formed by modernism and the historical avant-gardes. With the advent of postmodernism, the nuances of difference between the modernists and the avant-gardists disappeared, and the two groups began looking identical. Even when they repudiated history, they remained obsessed with it, whereas postmodernism records the end of modernity and history. Ever since its separation from realism in the mid-nineteenth century, modernism has accepted its exclusion from life and cultivated a religion of art, while the purpose of the avant-garde was to abolish the autonomy of art, reconcile it with life, and obliterate the gap between elitist and mass-market art; but from a postmodern viewpoint the avant-gardes were no more successful than the modernists. Because the avant-gardes continued to base the legitimacy of culture on innovation, it was elitist art they sought to democratize, and the result was the consolidation of the autonomy of art. Rather than wear itself out trying to democratize elite art, postmodernism aims to legitimate popular culture.

Do these arguments succeed in delineating the two sides, with modernism and the avant-gardes on one side and postmodernism on the other? The avant-gardist undertaking still seems to me irreducible to that of modernism: on the one hand, we have Proust, Joyce, and Woolf, Kafka and Mann, Eliot and

Pound—that is, the founding of a new tradition—and on the other, we have André Breton or rather Dada—that is, the negating of all tradition. Most of the modernists were politically indifferent or reactionary, while the avant-gardes, with some exceptions such as Italian futurism, leaned to the political left. It may well be that in the end the avant-gardes did nothing more than the humanists to challenge the autonomy of art, but how is it possible to cancel out the difference between their two views on time: the passion for the present and that for the future? But is it not just the passion for the future and the meaning of history that postmodernism abjures? Like Baudelaire, Nietzsche predicted the negative balance sheet of modern times, which he identified with decadence and linked with the insoluble contradiction between history and modernity. Postmodernity would then correspond to the end of historicity: no one now believes in the nineteenth-century philosophies of history, from Hegel to Auguste Comte, from Darwin to Marx, for like it or not, we are embarked on modernity in the sense of *hic et nunc*—even though our artists label themselves "postcontemporaries"—postmodernity would more specifically denote the renouncing of historical illusion.

Though modernity represented a passion for the present and the avant-garde an adventure in historicity, postmodern intentionality, which refuses to think of itself in historical terms, thus seems more hostile to the avant-garde than it does to modernity. Unless we are talking of its cynical and commercial variant—the latest metamorphosis of kitsch—postmodernism is not opposed to or incompatible with Baudelairean modernity, which has always been betrayed by avant-gardism, but to the idolatry of progress and the overcoming typical of the historical avant-gardes. Moreover and not irrelevantly, contemporary painting that uses the formal language stemming from the modernist movement, but with no hope that this language will lead anywhere, calls itself "post-avant-gardist."

A sharp distinction needs to be made, however, between the American postmodernism of the 1960s and the more global postmodernism of the 1980s. Though Calinescu's assessment of postmodernism changed in the decade from 1976 to 1986, the reason was that the object was no longer the same. Reacting against the modernism that was taught in universities and exhibited in museums, the earliest postmodern art—Rauschenberg and Jasper Johns in painting, Jack Kerouac and William Burroughs in literature, etc.—still represented an avant-garde movement. Modernism, writes Andreas Huyssen, had "become part of the liberal-conservative consensus of the times" and, particularly in the case of abstract expressionism, it had taken its place as "a propaganda weapon in the political-cultural arsenal of Cold War anticommunism." Postmodernism wanted therefore to press on with modernism as negation but to break with modernism as the established culture. The two discordant features of the avant-garde, iconoclasm and utopianism, were both present, which determined a new stage in the challenge to the art establishment: the rejection of the museum as the final refuge of elite art, including Duchamp's. The wish to combine art and life, optimism about technology, the valorization of mass culture, and the critical undertaking, all were of a piece with the European avant-garde tradition. Postmodernism, in the form of the American avant-garde of the 1960s, brought to an end the adventure of the international avant-gardes of the twentieth century.

The globalized post-1970 postmodernism is altogether different. It is clearly "post-avant-gardist" or "trans-avant-gardist," like the Italian movement in the plastic arts that goes by this name and which Henri Meschonnic considers to be representative of the postmodern. Reacting against "linguistic Darwinism" and "cultural evolutionism," this movement set out to combine the different avant-gardes, which seems the surest way to destroy them because it ignores their historicity. Trans-avant-gardism professed two values: the catastrophe, as an unprogrammed dif-

ference, and nomadism, as an uncommitted traveling over all areas and in all directions, including the past, without any sense of the future. Every feature of trans-avant-gardism makes it a denial of the avant-garde: iconoclasm and technological optimism are absent, and so is criticism of the media. The modern tradition is ransacked for its ideas and forms, which are juxtaposed with motifs from other sources such as popular art, and the result has been stored in a huge data bank from which the selection is made at random. "Everything is continually accessible," say the trans-avant-gardists, "with no more temporal or hierarchical categories of present and past typical of the avant-garde that has always experienced time by turning its back on it." The basic feature is still the "quotation," but it no longer plays a critical role as in the cubist collage or surrealistic and constructivist assemblage. What is exalted is the artist's subjectivity and the viewer's pleasure. The cult of the inauthentic triumphs over that of originality, and eclecticism presents itself as an overcoming in order to avoid being accused of neoacademicism.

Postmodernism can then take any form whatever. "Eclecticism," writes Lyotard, "is the degree zero of the level of general knowledge in our time . . . It is easy to find a public for eclectic works. But in becoming kitsch, art panders to the confusion that reigns in the 'taste' of the art lover. Artists, gallery owners, critics, and the public wallow together in the 'anything goes,' and our era is one of laxity."

3

It is tempting, given postmodernism's confusion, to react to it with severity and dignity. Such is Greenberg's attitude—which hardly comes as a surprise—in a lecture given in 1980. He sees postmodernism as merely an abdication, the renunciation of modern heroism and purism, the last word in kitsch and bad taste, and the epitome of the commercial corruption of art. Such also is the more unexpected attitude of Jean Baudrillard: "For nearly half a century, art has been negotiating for its own

disappearance" and the postmodern "quotation" is defined as the "pathological form of the end of art, a form that is weak and vapid." If the idea of time, whatever form it takes, is due to the ability to conceive of one's own death, postmodernity appears to be linked to an inability to represent death in the late-industrial world. With its lack of a sense of history, postmodernism seems to want to deny death. There is no dearth of condemnations of postmodernism; since in France, as some people say, these are tainted with xenophobia, one should perhaps look at them with a jaundiced eye.

It is true that the advocates of the postmodern, bound up in their inevitable paradoxes, are open to criticism—even Umberto Eco. He describes the return of the plot and the pleasure of reading that helped identify as postmodern his *Name of the Rose*—which, after all is structured like a good old whodunit— in terms that nullify any significance the reference might have. In an afterword to his novel he writes:

> I do not think that the postmodern can be delimited chronolog- ically: it is a mental category, or better, a *Kunstwollen,* a way of proceeding. One could say that a postmodern is found in every period, just as every period has a specific mannerism (to the point that I wonder whether the postmodern is not just the modern name for mannerism as a metahistorical category).

Thinking historically of a movement that wants to be outside of history and beyond historicity may well be a challenge, but relating the postmodern to a transhistorical generality resolves nothing. All the less so when Eco follows with a vast fresco in which he rediscovers all the commonplaces of genetic histori- cism as it views the modern tradition:

> The past conditions us, weighs on our shoulders, and makes us sing. The historical avant-garde destroys the past . . . seeks to send the past packing, disfigures it. A gesture typical of the avant-garde is the *Demoiselles d'Avignon*; then the avant-garde goes further yet and, after deconstructing the image, destroys it

and arrives at abstraction, the formless, the blank canvas, the torn-up canvas, the burned-up canvas; in architecture, it is the minimal state of the curtain wall, the building as stele, pure parallelepiped; in literature, it is the destruction of the discursive flow, to the point of the Burroughs-style collage, to silence or the blank page; in music, the transition from atonality to noise to absolute silence. . . .

The moment comes, however, when the avant-garde (the modern) can go no further, after which it ends up producing a metalanguage in which to speak its impossible texts (conceptual art). The postmodern response to the modern consists in pointing out that the past, being indestructible since its destruction leads to silence, must be revisited ironically, in a noninnocent way.

What a caricature! Paradoxically Eco resorts to the most orthodox narrative of the modern tradition in order to justify postmodernity. His confusion of the modern and the avant-garde is constant. Eco's view of history is always linear and progressive, even though he may be proposing a metahistorical approach. That is surely not the way to get anywhere in considering the relations between the postmodern and the modern or between the postmodern and history. We should also note the irony and lack of innocence Eco attributes to the postmodern: these two traits have *always* been modern, or at any rate in its most lucid representatives, from Poe and Baudelaire to Le Corbusier himself, the architect if not the urbanist.

Perhaps there is no way out of the fundamental ambiguity of the postmodern: ultramodern and antimodern, postmodernism regrets that the negativity of modernism has always been co-opted by the elite, and at the same time it proposes a bland eclecticism. This duality is the very one described in the quotation from Eco. But let not us not dwell on the paltry terms the postmodernist aesthetic may take; modernism was not spared by mediocrity either. And postmodernism is the result of a fundamental crisis in the consciousness of history in the contempo-

rary world, of a crisis of legitimacy regarding the modern ideals of progress, reason, and overcoming. In this sense it may represent the belated advent of true modernity.

To consider the postmodern without echoing the logic of the modern seems nonetheless an impossible feat. Nearly every defense of the postmodern tends to self-destruct. In *La Condition Postmoderne* Lyotard termed postmodern the lack of belief in the great narratives that for two centuries legitimated all knowledge and involved a philosophy of history. He identifies postmodernity with a state of general crisis concerning the legitimacy of knowledge and with the destabilization of the great determinisms. He distinguished between two theoretical models that until recently were dominant, one organic and the other dialectical: functional sociology or systems theory on the one hand, and Marxism on the other. But these models were at cross purposes and canceled each other out, the class struggle having become a principle of regulation absorbed by liberal capitalism, while in the name of Marxism the communist societies tended to stifle differences. The great narrative of humanity's emancipation and securement of freedom lost its unifying and legitimating power: the discourse of progress and the Enlightenment that had developed since the eighteenth century. Beyond its aesthetic aspects, postmodernity takes a new look at Enlightenment thinking without accepting the idea of a unitary end of history; it calls into question the modern ideal of reason because of its supposed share of responsibility for its disastrous effects, including Nazism.

"One name seals the end of the modern ideal: Auschwitz," asserts Lyotard unhesitatingly. This is going a bit fast; must we leap so quickly from the criticism of the culture to the condemnation of reason in the name of the "final solution" (forgetting the breakup of the Bauhaus under Hitler and the condemnation of modern art as degenerate)? Is the Enlightenment responsible for the evil of modern times? It is easy to destroy the idols one

has worshiped, but Lyotard cannot quite free himself of the genetic-historical model. In explaining the ambivalence inherent in the postmodern, he unhesitatingly resorts to the most orthodox narrative of the modern tradition.

> It is undoubtedly a part of the modern. All that has been received, if only yesterday (*modo, modo* Petronius used to say), must be suspected. What space does Cézanne challenge? The Impressionists'. What object do Picasso and Braque attack? Cézanne's. What presupposition does Duchamp break with in 1912? That which says one must make a painting, be it cubist. And Buren questions that other presupposition which he believes had survived untouched by the work of Duchamp: the place of presentation of the work in an amazing acceleration that the generations precipitate themselves. A work can become modern only if it is first postmodern. Postmodernism thus understood is not modernism at its end but in the nascent state, and the state is constant.

Even though Lyotard adds that he will not confine himself to the "slightly mechanistic meaning of the word," he should not even be suggesting it at all, for what in fact we find here, without the least hint of objectivity, is the dogma of evolution. Once on this path, Lyotard does not stop here. He writes that if modernity is the rejection of realism, suspended between what is presentable and what is conceivable, then "the postmodern would be that which, in the modern, puts forward the unpresentable in the presentation itself; that which denies itself the solace of good forms." The postmodern is here seen as the truth of the modern, as the attainment of the still unrealized possibilities in the modern and, therefore, as yet another overcoming in the movement toward the essence of art.

The question arises why Habermas so harshly attacked French thinking when he assimilated postmodernism with neoconservatism; the two movements may well be drawn together by their common belief in the decline of ideologies and historical

dreams, and the defenders of the modern tradition readily equate them. Or again, a neo-Marxist such as Fredric Jameson, for whom postmodernism reinforces the logic of capitalism by denying the autonomy of art, which represents, consistent with Adorno, the final guarantee against its co-optation by the bourgeois. Postmodernism discarded modernism's critical or subversive dimension in favor of a simple cohabitation with the postindustrial society. Without being specific, however, Jameson leaves open the question whether postmodernism might not also resist the logic of capitalism.

Habermas dramatically linked postmodernism with neoconservatism in a 1980 lecture called "Modernity: An Unfinished Project." He attacked both social neoconservatism and artistic postmodernism as two aspects of the same abdication in the face of modernism, conceived in the tradition of the Enlightenment but purged of its nihilistic elements. According to Habermas the neoconservative position conflates the incompleteness of modernity with its failure. To clear up this confusion he attempts to restore the universal liberating power of enlightened reason, a precondition of democracy, against those who would liken reason to totalitarianism. This defense of an enlightened and positive modernity, later elaborated in his *Philosophical Discourse of Modernity,* attacks in particular the philosophy of Georges Bataille, Michel Foucault, and Jacques Derrida, up to the ephemeral *nouveaux philosophes,* all considered perpetrators of a new form of obscurantism.

If modernity is the pursuit of the Enlightenment, as Habermas would have it, does cultural eclecticism always stem from political conservatism? Is the postmodern necessarily based on a rejection of reason? In order to show the error of equating postmodernism and neoconservatism, Huyssen stresses that American postmodernism, whose eclectic ferment includes minority cultures once snubbed by modernism, is an answer to the hopes of the faithful from the 1960s counterculture. But this medley either cancels out critical power or replaces it with fellowship

and goodwill, as can be seen in Jean-Paul Goude's production of *La Marseillaise* for the July 14, 1989, bicentennial celebration of the storming of the Bastille, in which regionalism and cosmopolitanism coexisted nicely among some quotations from various origins whose assemblage no longer spelled fireworks.

Let us grant Habermas that the diatribe against reason has become a cliché among contemporary French essayists, such as Gilles Lipovetski in his *Ere du vide*: "Postmodern society means . . . disenchantment and the monotony of the new. . . . No longer can any political ideology fire up the masses. . . . From now on we are governed by the void, a void that is nonetheless neither tragic nor apocalyptic." The old refrain. It has become stylish to spit on the moderns. To be more serious, the dispute between Habermas and French poststructuralism reveals a disagreement about the meaning of the idea of the modern. In France the modern is understood as the modernity that began with Baudelaire and Nietzsche and therefore includes nihilism. Because of its distrust of progress the modern was from the start ambivalent in its relationship with modernization and particularly with history; it is essentially an aesthetic stance. This, we may add, is the reason for the other misunderstanding—this time between the French and the Americans—the fact that modernity in the French sense, Baudelairean and Nietzschean, includes postmodernity. In Germany, on the other hand, the modern begins with the Enlightenment and to renounce it means to forsake the ideals of the *philosophes*. This contradiction cannot be resolved simply by arguing for some continuity that goes smoothly from the Enlightenment, on through the Jacobins, Hegel, and Marx, and finally to the Gulag. That there is such a thing as a conservative postmodernism is evident, but this should not disguise the fact that the postmodernist consciousness, refuting historicism and the dogma of progress, is also linked to the origins of modernity. The crucial point is the critical stance. There is also an uncritical postmodernism: eternal kitsch. On the other hand, critical postmodernism

rediscovers true modernity. Or perhaps it may be that my iden-
tification of good postmodernity with Baudelairean modernity
simply reflects my French chauvinism.

But Gianni Vattimo also sees a close correspondence between
postmodern theory and, if not Baudelaire, at any rate two other
critiques of classic modern philosophy: Nietzsche's doctrine of
the eternal return and Heidegger's "overcoming" of meta-
physics. The essence of postmodernity is its rejection of the idea
of the modern par excellence, that of "overcoming," just as
Nietzsche and Heidegger called the heritage of European
thought radically into question "but at the same time refuse[d]
to propose a means for a critical 'overcoming' of it. For both
philosophers, the main reason for this refusal is that any call for
an 'overcoming' would involve remaining captive to the logic of
development inscribed in the tradition of human thought."
Postmodernity would thus represent an authentic turning point
in relation to modernity. "The 'post-' in the term *postmodern*
indicates in fact a taking leave of modernity. In its search to free
itself from the logic of development inherent in modernity—
namely the idea of a critical 'overcoming' directed toward a new
foundation—postmodernity seeks exactly what Nietzsche and
Heidegger seek in their own peculiar 'critical' relationship with
Western thought." Of all the interpreters of the postmodern,
Vattimo seems to accord it the greatest philosophical value, that
of a leave-taking of the modern, not by overcoming or taking
over, but by a "getting over," in the way we recover from an
illness.

Therefore, postmodernity appears not so much as one more
crisis among others marking the course of the history of moder-
nity, the latest to date of the modern negations, or the most
recent episode in the revolt of modernism against itself, but as
the very denouement of the modern epic, the realization that
the "modern project," as Habermas called it, will never be com-
pleted. But an end to the belief in progress does not imply an

apocalyptic fall into irrationality. With its "weak ontology," says Vattimo, postmodernity simply proposes a different way of thinking about the relationship between tradition and innovation, or between imitation and originality; but out of principle it no longer privileges innovation and originality. A long series of modern contrasts lose their cutting edge: new/old, present/past, left/right, progress/reaction, abstraction/representation, avant-garde/kitsch. The postmodern consciousness also makes it possible to reinterpret the modern tradition without seeing it as a conveyor belt and the great adventure of the new. The moment messianism becomes obsolete, all the contradictions appear, all the chance events, all the resistances of modernism to its forward march. We have recovered from the teleological view of modernism, which does not mean that "anything goes," but, more modestly, that one can no longer reject a work simply because it has been surpassed or is retrograde. If, from one critical overcoming to another, art does not pursue some goal of sublime abstraction, as the orthodox narratives of the modern tradition would have it, we can now enjoy a freedom unknown for more than a century. Obviously, it is not easy to make use of this freedom!

CONCLUSION:
A RETURN TO BAUDELAIRE

Modern art is paradoxical. I have tried to explore some of the aporias of the aesthetic of the new that explain both its greatness and its decline. As early as the start of the nineteenth century, Hegel judged that the glory of art was past, and he announced the end of art. Is it this end, always being put off for close to two hundred years, that we are witnessing today? The avant-gardes ignored Hegel's prognosis; they tried to give art a present and future ideal. But faith in the new was based on so many contradictions that it destroyed itself, and we seem to have come full circle, from the break with tradition to the tradition of rupture, and finally to the break from rupture, which is our postmodernity.

No doubt the contradictions of modernity were set down from the beginning: Baudelaire and Nietzsche recognized them. Nevertheless, it was long believed that these contradictions could be scoffed at. Today they stand out clearly. Even if modernity has always wished for self-sufficiency, since the modern work only measures itself by its own standards, tradition remained secretly present, if only in the form of craftsmanship. But modern art, gradually eliminating acquired skills, did not replace them with any other kind of skill. Henceforth the hand has nothing more to break away from, and it is possible to be a painter without knowing how to paint.

Nihilistic and futuristic, always guided by a theory, the historical avant-gardes believed in a direction and destination of artistic development, but the pop art of the 1960s and then the "anything goes" of the 1970s freed art from the imperative of innovation. We are cured of the modern historical malady diagnosed by Nietzsche. Art has finally attained its true self-sufficiency, always proclaimed but hitherto unrealized. It abolishes every boundary between what is acceptable and what is not, throwing out every definition, positive or negative, of what constitutes a work of art. What has completely replaced the art object is our relation to it, with the result, also paradoxical, that complete freedom in art entails a narrowing of its possibilities: how many colors have been lost in the past fifty years? They have vanished like so many other living species. The freedom of the contemporary artist no longer entails any social responsibility, for the market and the media have now accomplished what the avant-gardes, always ambiguous in the face of elitist art, never dared to do.

Art has been central to the modern consciousness because the new, as the fundamental value of the age, has long found its justification in it. Faith in progress means faith in the new as such, as form rather than content. Because the modern era is open-ended, progress—an empty value in itself—has no other meaning than to make progress possible. Hence progress inevitably becomes a matter of routine and thus nullifies the ideal of progress. "But where, I ask you, is the guarantee that this progress will continue beyond tomorrow?" asked Baudelaire in 1855: "It exists, I tell you, only in your credulity and fatuousness." Art has been able only to preserve the pathos of the new and salvage faith in progress. But the discrediting of the new, having now invaded the realm of art, testifies at last to a lucid awareness of modernity, that of Baudelaire, who understood that the secular ideal of progress implied "the identity of the two contradictory ideas of freedom and inevitability." "This

identity," he adds in *My Heart Laid Bare,* "is history." Having now recovered from history, we have indeed come back to Baudelaire.

This means that the issue we face is not so much the end of art—which has survived itself for close to two centuries—as the bankruptcy of the doctrines that attempted to explain it. Modernist and avant-gardist theories remained classical, forming a teleological history conceived as a critical progression toward some end. Curiously enough, the modernist vocabulary belonged entirely to the classical tradition: *history, essence, reduction, purification, reason, progress,* and so forth. Orthodox narratives such as those of Greenberg were Kantian in inspiration, defining art as an autonomous activity that progresses by means of self-criticism. With postmodernity, we are simply making up for the lagging behind in our own thinking about art since Baudelaire. This time lag has been characteristic of the modern illusion. In this sense, our own fin de siècle also represents a return to Nietzsche, who based his genealogy of the classical tradition on the observation that progress no longer had any meaning for modern man, that history was opened onto a void. Today, art shows this void without having to worry about where it is going.

But how can we account for the modern tradition without a doctrine of progress, without a historical awareness that perceives the stages, the successive aporias, in terms of causes, effects, or critical overcomings? Having renounced genetic historicism, how can we not not end up with a leveling out of values, and cry out in turn: "Anything goes"? If value is no longer identified with the new, the very legitimacy of my own narrative, which still makes choices, is in question. Every narrative depends on the outcome that one wishes to give it. Without an outcome to propose, how does one maintain a narrative? If the work is valuable in itself and not because of its place in history, how do we evaluate a series of unconnected works? Beyond the

self-referentiality and self-sufficiency of art that challenges its own status, the criterion becomes irony. Baudelaire wrote that Delacroix, like Stendhal, "was terrified of being made a fool of." My own preferences run to artists who were not fooled by modernity.

BIBLIOGRAPHY

Adorno, Theodor W. *Théorie esthétique.* French trans. Paris: Klincksieck, 1974. Translated by C. Lenhardt, under the title *Aesthetic Theory.* London and Boston: Routledge and Kegan Paul, 1984.

——. *Notes sur la littérature.* French trans. Paris: Flammarion, 1984. Translated by Shierry Weber Nicholsen, under the title *Notes to Literature.* New York: Columbia University Press, 1991.

Apollinaire, Guillaume. *Les peintres cubistes: Méditations esthétiques.* Paris: Hermann, 1965. Translated by Lionel Abel, under the title *The Cubist Painters: Aesthetic Meditations.* New York: Wittenborn, Schultz, 1949.

Aragon, Louis. *Traité du style.* Paris: Gallimard, 1928. Translated by Alyson Waters, under the title *Treatise on Style.* Lincoln: University of Nebraska Press, 1991.

——. *Les Collages.* Paris: Hermann, 1965.

Aron, Jean-Paul. *Les Modernes.* Paris: Gallimard, 1965.

"Avant-garde et modernité." *Littérature moderne* 1 (1988).

Barth, John. *The Literature of Exhaustion and the Literature of Replenishment.* Northridge, Calif.: Lord John's Press, 1982.

——. "La littérature du renouvellement." *Poétique* 48 (November 1981).

Barthes, Roland. *Le Degré zéro de l'écriture.* Paris: Editions du Seuil, 1953. Translated by Annette Lavers and Colin Smith under the title *Writing Degree Zero.* New York: Hill and Wang, 1968.

Baudelaire, Charles. *Oeuvres complètes.* Edited by Claude Pichois. Paris: Gallimard/Pleïade, 1975–1976.

Bell, Daniel. *The Cultural Contradictions of Capitalism.* New York: Basic Books, 1978.

Benjamin, Walter. *Poésie et révolution.* French trans. Paris: Denoël, 1971.

Blake, Peter. *Form Follows Fiasco: Why Modern Architecture Hasn't Worked.* Boston: Little, Brown, 1977.

Bois, Yves-Alain. "Modernisme et postmodernisme." In *Encyclopaedia Universalis, Symposium, Les Enjeux*. Paris: , 1988.

Breton, André. *Oeuvres complètes*. Vol. 1. Edited by Marguerite Bonnet. Paris: Gallimard/Pleïade, 1988.

Bürger, Peter. *Theory of the Avant-Garde*. Translated by Michael Shaw. Minneapolis: University of Minnesota Press, 1984.

Calinescu, Matei. *Five Faces of Modernity: Modernism, Avant-Garde, Decadence, Kitsch, Postmodernism*. Durham: Duke University Press, 1987.

Clair, Jean, ed. *Marcel Duchamp: Catalogue raisonné de l'oeuvre*. Paris: Musée national d'art moderne, 1977.

——. *Considérations sur l'état des beaux arts: Critique de la modernité*. Paris: Gallimard, 1983.

Compagnon, Antoine. *Proust entre deux siècles*. Paris: Editions du Seuil, 1989. Translated by Richard E. Goodkin, under the title *Proust Between Two Centuries*. New York: Columbia University Press, 1992.

Crow, Thomas. "Modernisme et culture de masse dans les arts visuels." *Les Cahiers du musée national d'art moderne* 19–20 (June 1987).

Daix, Pierre. *L'Aveuglement devant la peinture*. Paris: Gallimard, 1971.

——. *L'Ordre et l'aventure*. Paris: Arthaud, 1984.

Damisch, Hubert. *Fenêtre jaune cadmium*. Paris: Editions du Seuil, 1984.

De Man, Paul. "Lyric and Modernity." In *Blindness and Insight: Essays in the Rhetoric of Contemporary Criticism*. Minneapolis: University of Minnesota Press, 1983.

——. "What is Modern?" In *Critical Writings: 1953–1978*. Minneapolis: University of Minnesota Press, 1983.

Duchamp, Marcel. *Duchamp du signe*. Paris: Flammarion, 1975.

Eco, Umberto. *Apostille au "Nom de la rose"*. Paris: Librarie Générale Française, 1987.

Ellman, Richard, and Charles Feidelson, Jr. *The Modern Tradition: Backgrounds of Modern Literature*. New York: Oxford University Press, 1965.

Enzenberger, Hans Magnus. "The Aporias of the Avant-Garde." In *Issues in Contemporary Literary Criticism,* edited by Gregory Polletta. Boston: Little, Brown, 1973.

Friedrich, Hugo. *Structures de la poésie moderne*. French trans. Paris: Denoël/Gonthier, 1976. Translated by Joachim Neugroschel, under the title *The Structure of Modern Poetry: From the Mid-Nineteenth to the Mid-Twentieth Century*. Evanston: Northwestern University Press, 1974.

Gablik, Suzi. *Has Modernism Failed?* New York: Thames and Hudson, 1984.

Greenberg, Clement. *Art et Culture*. French trans. Paris: Macula, 1988. American edition, *Art and Culture: Critical Essays*. Boston: Beacon Press, 1961.

———. *The Notion of "Postmodern".* Sydney: Bloxham and Chambers, 1980.

Guilbaut, Serge. *Comment New York vola l'idée d'art moderne.* Nîmes: Chambon, 1980. Translated by Arthur Goldhammer, under the title *How New York Stole the Idea of Modern Art: Abstract Impressionism, Freedom, and the Cold War.* Chicago: University of Chicago Press, 1983.

Habermas, Jürgen. *Le Discours philosophique de la modernité.* French trans. Paris: Gallimard, 1988. Translated by Frederick G. Lawrence, under the title *The Philosophical Discourse of Modernity: Twelve Lectures.* Cambridge: MIT Press, 1987.

———. "La Modernité: Un projet inachevé." French trans., *Critique* 413 (October 1981). English trans., "Modernity Versus Postmodernity," *New German Critique* 22 (Spring 1981): 3–22.

Hassan, Ihab Habib. *The Dismemberment of Orpheus: Toward a Postmodern Literature.* 2d ed. Madison: University of Wisconsin Press, 1982.

Hess, Thomas B., and John Ashberry, eds. *Avant-Garde Art.* New York: Collier, 1967.

Howe, Irving. *The Decline of the New.* New York: Harcourt, Brace, and World, 1970.

Huyssen, Andreas. *After the Great Divide: Modernism, Mass Culture, Postmodernism.* Bloomington and Indianapolis: Indiana University Press, 1986.

Jameson, Fredric. "Postmodernism or the Cultural Logic of Late Capitalism." *New Left Review* 146 (July/August 1984).

Jauss, Hans Robert. "La 'modernité' dans la tradition littéraire et la conscience d'aujourd'hui." In *Pour une esthétique de la réception.* French trans. Paris: Gallimard, 1978. Translated by Timothy Bahti, under the title *Toward an Aesthetic of Reception.* Minneapolis: University of Minnesota Press, 1982.

Jeauneau, Edouard. "Nains et géants." In *Entretiens sur la Renaissance du douzième siècle,* edited by Maurice de Gandillac and Edouard Jeauneau. Paris and the Hague: Mouton, 1968.

Jencks, Charles A. *The Language of Post-Modern Architecture.* New York: Rizzoli, 1977.

Kandinsky, Wassily. *Regards sur le passé et autres textes, 1912–1922.* Paris: Hermann, 1974.

———. *Du Spirituel dans l'art et dans la peinture en particulier.* French trans. Paris: Denoël, 1989. Translated by M. T. H. Sadler, under the title *Concerning the Spiritual in Art.* New York: Dover Publications, 1977.

Lipovetski, Gilles. *L'Ere du vide: Essais sur l'individualisme contemporain.* Paris: Gallimard, 1983.

Lyotard, Jean-François. *La Condition postmoderne.* Paris: Editions du Seuil, 1979. Translated by Geoff Bennington and Brian Massumi, under the

title *The Postmodern Condition: A Report on Knowledge.* Minneapolis: University of Minnesota Press, 1984.

——. "Réponse à la question: Qu'est-ce que le post-moderne?" *Critique* 419 (April 1982).

Malevitch, Kazimir. *Ecrits.* French trans. Paris: Lebovici, 1986.

Meschonnic, Henri. *Modernité, modernité.* Lagrasse: Verdier, 1988.

Nadeau, Maurice. *Histoire du surréalisme.* Paris: Editions du Seuil, 1964. Translated by Richard Howard, under the title *The History of Surrealism.* Cambridge: Belknap Press of Harvard University Press, 1989.

Nietzsche, Friedrich Wilhelm. *Seconde considération intempestive. De l'Utilité et de l'inconvénient des études historiques pour la vie.* French trans. Paris: Flammarion, "GF," 1988. Translated by Peter Preuss, under the title *On the Advantage and Disadvantage of History for Life.* Indianapolis: Hackett, 1980.

"Notre histoire: Matériaux pour servir à l'histoire intellectuelle de la France, 1953–1987." *Le Débat* 50 (May/August 1988).

Paulhan, Jean. *Braque le patron.* Paris: Gallimard, 1952.

——. *La Peinture cubiste.* Paris: Denoël/Gonthier, 1970.

Paz, Octavio. *Marcel Duchamp: L'Apparence mis à nu. . . .* French trans. Paris: Gallimard, 1977. Translated by Rachel Phillips and Donald Gardner, under the title *Marcel Duchamp: Appearance Stripped Bare.* New York: Viking, 1978.

——. *Point de convergence: Du romantisme à l'avant-garde.* French trans. Paris: Gallimard, 1976. Translated by Helen Lane, under the title *Convergences: Essays on Art and Literature.* San Diego: Harcourt Brace Jovanovich, 1987.

Picon, Gaëtan. *1863: Naissance de la peinture moderne.* Geneva: Skira, 1974.

——. *Le Surréalisme.* Geneva: Skira, 1974.

Pleynet, Marcelin. *Art et littérature.* Paris: Seuil, 1977.

Poggioli, Renato. *The Theory of the Avant-Garde.* Translated by Gerald Fitzgerald. Cambridge: Belknap Press of Harvard University Press, 1968.

Portoghesi, Paolo. *La presenza des passato: Prima mostra internazionale di architettura.* Venice: La Biennale di Venezia, 1980.

——. *Postmodern: L'architettura nella società post-industriale.* Milan: Electa, 1982. Translated by Ellen Shapiro, under the title *Postmodern: The Architecture of the Post-Industrial Society.* New York: Rizzoli, 1983.

Reff, Theodore. *Manet: Olympia.* New York: Viking, 1977.

Robbe-Grillet, Alain. *Pour un nouveau roman.* Paris: Editions de Minuit, 1962. Translated by Richard Howard, under the title *For a New Novel: Essays on Fiction.* New York: Grove Press, 1965.

Rosenberg, Harold. *La Tradition du nouveau.* French trans. Paris Editions de

Minuit, 1963. Originally published as *The Tradition of the New.* New York: Horizon, 1959.

——. *The Anxious Object: Art Today and its Audience.* New York: Horizon Press, 1964.

——. *The De-Definition of Art: Action Art to Pop to Earthworks.* New York: Horizon Press, 1972.

——. *Art on the Edge: Creators and Situations.* New York: Macmillan, 1975.

Rowe, Colin and Fred Koetter. *Collage City.* Cambridge: MIT Press, 1978.

Sarraute, Nathalie. *L'Ere du soupçon.* Paris: Gallimard, 1956. Translated by Maria Jolas, under the title *The Age of Suspicion: Essays on the Novel.* New York: George Braziller, 1963.

Seuphor, Michel. *La Peinture abstraite: Sa genèse, son expansion.* Paris: Flammarion, 1962. Translated by Haakon Chevalier, under the title *Abstract Painting: Fifty Years of Accomplishment, from Kandinsky to the Present.* New York: Abrams, 1962.

——. *Piet Mondrian.* Paris: Séguier, 1987.

Shattuck, Roger. *The Banquet Years: The Origins of the Avant-Garde in France, 1885 to World War I.* New York: Harcourt Brace, 1958.

Vallier, Dora. *L'Art abstrait.* Paris: Librarie Générale Française, 1980.

Vattimo, Gianni. *La Fin de la modernité: Nihilisme et herméneutique dans la culture post-moderne.* French trans. Paris: Editions du Seuil, 1987. Translated by Jon R. Snyder, under the title *The End of Modernity: Nihilism and Hermeneutics in Post-Modern Culture.* Cambridge: Polity Press in association with B. Blackwell, 1988.

Venturi, Robert. *De l'Ambiguïté en architecture.* French trans. Paris: Dunod, 1971. Originally published as *Complexity and Contradiction in Architecture.* 2d ed. New York: Museum of Modern Art in association with the Graham Foundation for Advanced Studies in the Fine Arts, Chicago; distributed by the New York Graphic Society, 1977.

Venturi, Robert, Denise Scott Brown, and Steven Izenour. *L'Enseignement de Las Vegas.* French trans. Brussels: Mardaga, 1978. Originally published as *Learning from Las Vegas: The Forgotten Symbolism of Architectural Form.* Cambridge: MIT Press, 1977.

INDEX

Designer: Linda Secondari
Text: 11/13 Garamond 2
Compositor: Impressions, A Division of
Edwards Brothers, Inc.
Printer: Edwards Brothers, Inc.
Binder: Edwards Brothers, Inc.